whittling simplified: everything you need to know

A comprehensive handbook for the beginning and experienced Whittler. Hand-drawn illustrations and hand-lettered text by the author provides all of the information to produce useful and decorative works of art. Includes a Three-Link Chain, Ball-In-Cage, Swivels and Slip-Joints, Chain Variations, Folding Knives, a variety of Fishes, and extensive details about Gnomes. A total of 21 projects for different Whittling interests with instructions on how to draw the patterns to be used for the projects. How-To-Do-It information is included for the preparation and use of the tools required for Whittling and detailed instructions for making the special tools that are important to the Whittler.

HERB REINECKE

ALMAR PRESS
4105 Marietta Drive
Binghamton, N.Y. 13903

Library of Congress Cataloging-in-Publication Data

Reinecke, Herb, 1922–
 Whittling simplified.

 Bibliography: p.
 Includes index.
 1. Wood-carving. I. Title.
TT199.7.R45 1985 736′.4 85-11136
ISBN 0-930256-14-X

This text was initially privately published by the author in four small booklets entitled "Whittling Simplified" and "Whittling Projects & Patterns" Book 1, 2, 3.

First Edition, First Printing August 1985

Second Printing August 1987
Third Printing October 1989
Fourth Printing July 1990
Fifth Printing October 1991

Cover design by The Art Department, Binghamton, NY
Composition Production by Eastern Graphics, Binghamton, NY

Printed in the United States of America

table of contents

list of illustrations

preface

Try your hand at whittling. The tips and suggestions offered here are to help start you on the age old hobby of whittling. All you need is a pocket knife, a scrap of wood, and the urge to create.

Don't be discouraged if your first few pieces are not quite to your liking. Keep practicing — you will soon develop the skill to turn out good work.

Take your time, don't rush. Whittling is something to be enjoyed.

Herb Reinecke

Melbourne, Florida

dedication

Dedicated to my loving and understanding wife, Bunny, who tolerates and cleans up the wood chips after me.

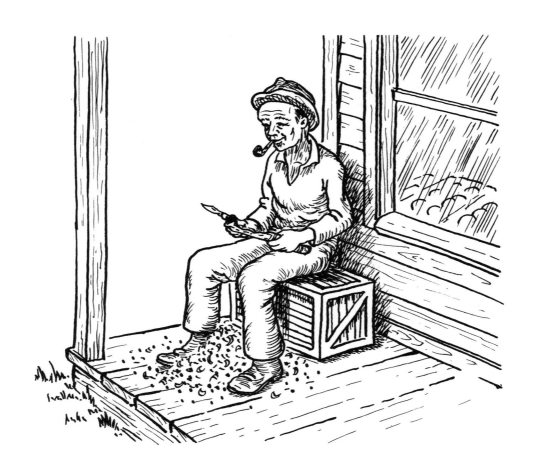

introduction

What is the difference between woodcarving and whittling ? This question has been asked many times. Sculpture in wood is carving. It is how the carving or sculpture is done that determines whether woodcarving or whittling is employed. To sum it up in a simple way – woodcarving is the art of creating in wood using, primarily, chisels and gouges struck with a mallet, whereas whittling is the art of creating in wood using primarily a knife blade.

In many instances there will be an overlap of both crafts but the primary method used would dictate the correct terminology.

Webster's New World Dictionary defines whittling as ; to cut or pare thin shavings from wood with a knife, to make or fashion an object in this manner.

The word whittling conjures up a vision of an old timer sitting on a crate outside the general store, a pocket knife in one hand, a stick in the other, and a huge pile of shavings at his feet.

Cutting away aimlessly on a stick of wood is a form of whittling but it is a non-productive form.

Whittling is also creating beauty in a lasting form. Whether the object be utilitarian or decorative, the craftsman leaves part of himself in the warmth and glow of the wood.

The origin of whittling is lost in history. One can imagine however that early man whittled out a hunting weapon from a stick of wood using nothing more than a broken piece of clamshell or a sharp-edged stone as a knife.

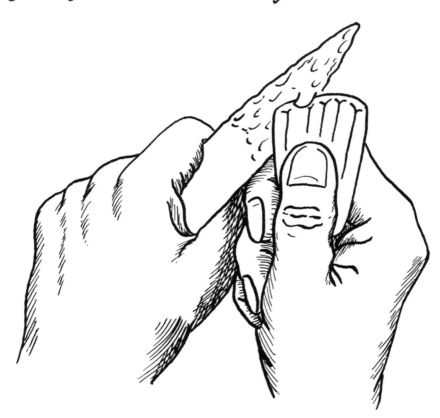

After man discovered how to forge metal into knife blades he could carve and whittle wood to create utensils, create adornments for his home, create images of his gods for his temples, and even create dolls and animals to amuse his children.

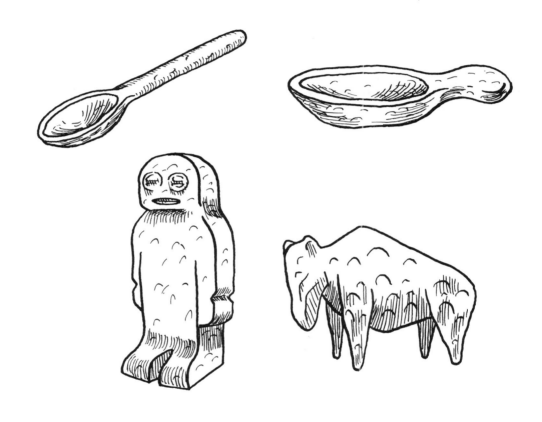

Carving in wood has been an occupation and a hobby for over 4,000 years. The wooden sculptures of ancient Egypt still survive today attesting the skill of the artisan and of the permanence of wood. Many

of the beautiful wood sculptures of the Renaissance period of the 14th, 15th, and 16th centuries, when wood carving flourished, can still be seen in cathedrals and palaces where they were done or in museums.

Down through the ages the knife has been a companion to man. Even today activities such as scouting and other youth organizations teach our young the fundamentals of using and caring for the knife.

knives

The basic requirement for whittling is a good quality, sharp edged knife.

There are many types of knives to choose from and the choice can often be confusing.

Let's start with the common pocket knife. This type of knife has the distinct advantage that the blades will fold into the handle thus making it easy to carry with you at all times. Incidently, the folding blade can also inflict a nasty cut if it should accidently close on itself due to improper use.

Pocket knives are available from a single blade type to the multiple blade type which include scissors, nail-files, bottle openers, etc. If you are going to purchase a knife, settle for two blades, or three at the most. Buy a good one. There are several good brands on the market, including 'Case', and 'Buck' but to name two. True, they may cost more but they are worth it. They are constructed of quality steel and are able to hold a sharpened edge much longer than a cheaper brand.

The blade shapes are important. Illustrated are seven of the more common shapes in pocket knives.

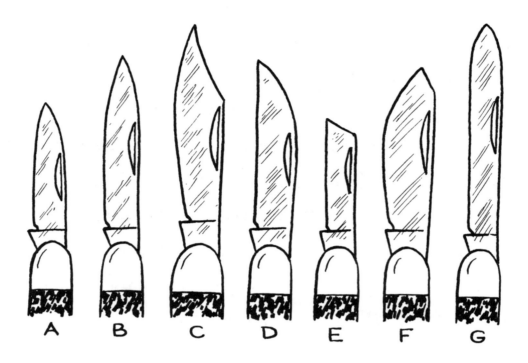

The most convenient shapes are A, B, and E. I prefer to modify the A and B shape to make the blade more versatile.

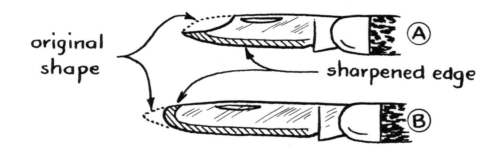

The modified point in 'A' allows a narrower deep cut, while the sharpened rounded point of 'B' allows cutting across the grain in tight places with ease. The blade marked 'E' is useful for incising straight deep lines.

Individual preference will vary. If you can work comfortably with other blade shapes, by all means do it.

A type of knife that is a favorite of many is the X-Acto brand or similar type knife with aluminum or plastic handles that accept a variety of replaceable blades. There are four basic handles:

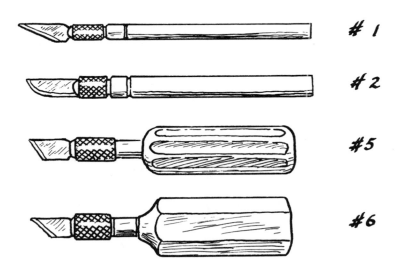

#1

#2

#5

#6

The #1 handle is slim and will hold only smaller blades like #'s 10, 11, or 16. The #'s 2, 5, and 6 handles will accomodate the larger blades. The styles of blades available exceed the few that are shown here.

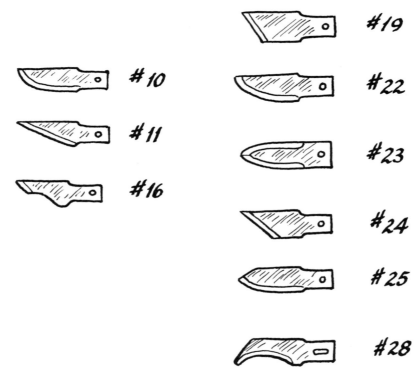

#19

#10

#22

#11

#23

#16

#24

#25

#28

The X-Acto brand also has a beautiful set of six knives known as the 'Deluxe Whittler's Knives'. The handle can be bought separately. The blades are replaceable and are sold two of the same style to the package.

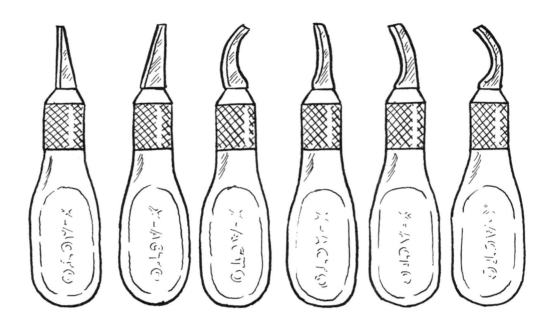

Many whittlers use nothing more than a Sloyd knife, sometimes known as a bench knife.

A SLOYD KNIFE

There are many and various blade shapes available under the names of carving knives, whittling knives, manual training knives, bench knives, etc. They are bench tools as compared to pocket knives. They do have the advantage of not folding closed accidently.

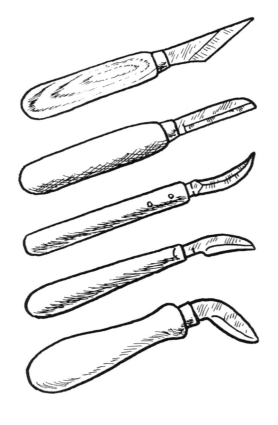

SOME OF THE
WIDE ASSORTMENT
OF KNIVES
AND BLADE SHAPES
AVAILABLE

I hesitate to recommend any one type of knife. All of the aforesaid are excellent. I have used them all. You will find you can do a lot using any one of the knives. At other times you will find an advantage in using more than one.

Personal preference will decide which is best for you.

sharpening

The single most important thing in whittling is the sharpness of the knife edge. If the blade does not cut properly, it isn't the tool that's at fault, it is due to improper sharpening.

Most knives appear sharp when bought but they must be sharpened before using them. They also require resharpening as they are used.

Correct sharpening is a patient, time-consuming, almost scientific chore which can be mastered, but there is a more simplified way however to sharpen a blade to a keen, long-lasting edge. It is not difficult to learn.

Three stones are needed plus a can of light oil or a can of honing oil.

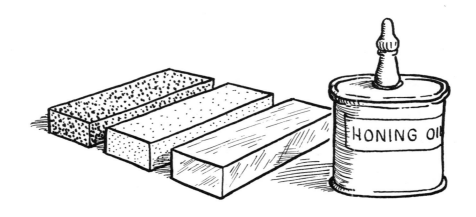

The oil helps prevent the stone from glazing over with imbedded metal particles. It aids the cutting action of the stone.

The first stone should be of medium grit, the second, much finer, and the third should be a hard Arkansas stone.

The angle that the blade rubs against the stone is of prime importance. Lay the blade flat on the stone, then raise the heel about 10 degrees.

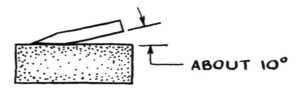

ABOUT 10°

Maintain this angle throughout the sharpening procedure. This will give you a long thin cutting edge which is best for whittling woods such as white pine and basswood. (If you wish to whittle woods such as walnut, cherry, or other harder woods, the blade angle should be increased to 15 degrees or more resulting in a shorter bevel.)

With the blade thus raised, add a few drops of oil to the stone and rub the blade in a circular motion.

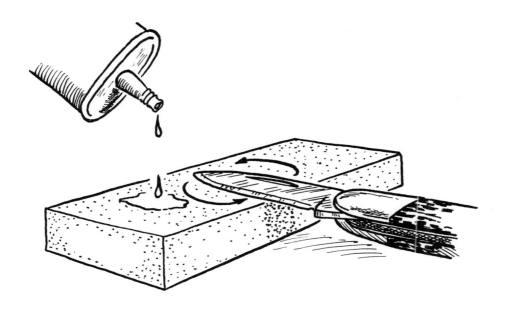

Rub one side of the blade, then the other, then back to the first side again, etc. Just be sure you keep the blade and the stone at the same angle.

Use the medium stone first. This will shape the steel to the desired bevel. Relax, it may take a little time to wear down the steel. You need only to use this stone if your knife is extremely dull, or to lengthen the bevel on a new blade.

This medium stone will produce a wiretooth edge.

Using the finer grit stone, repeat the same operation until the wire-edge is gone. Usually about a dozen passes on each side over the stone will accomplish this.

The final step is using the hard Arkansas stone. Keeping the same 10 degree angle touch up the blade on both sides alternately to produce a keen polished edge.

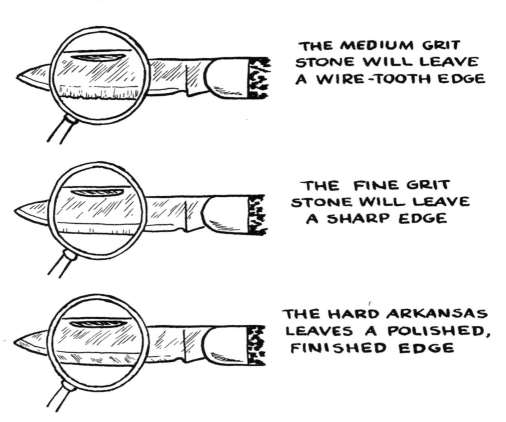

THE MEDIUM GRIT STONE WILL LEAVE A WIRE-TOOTH EDGE

THE FINE GRIT STONE WILL LEAVE A SHARP EDGE

THE HARD ARKANSAS LEAVES A POLISHED, FINISHED EDGE

Touching up the blade occasionally on the hard Arkansas stone while whittling will restore the edge when it loses some of it's "bite". When this touch-up no longer works go back to the finer grit stone, rub the blade lightly on each side for a few strokes and then use the Arkansas to finish the edge.

other tools

There are other tools which are helpful and convenient. A bandsaw and jigsaw can save you a considerable amount of time and effort when sawing out blocks of wood or when sawing to an outline.

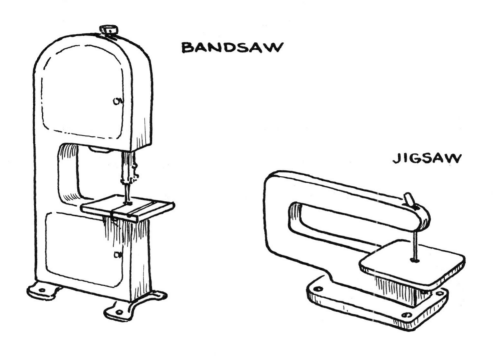

BANDSAW

JIGSAW

If you don't have or can't afford a bandsaw or a jigsaw, a small coping saw and a hand saw can do the same work although somewhat slower and with more effort. Some whittlers would never use anything but their knives, shunning all time and labor saving accessories.

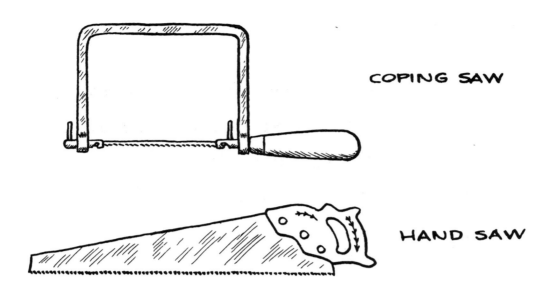

COPING SAW

HAND SAW

When sawing by hand to an outline the use of a clamp or a vise is required. Don't try to hold the wood in one hand while sawing with the other.

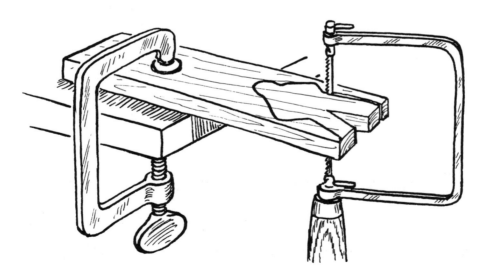

Coping saws cut on the pulling motion, not the pushing motion. Be sure the teeth point toward the handle.

The term sandpaper is commonly used to refer to an abrasive that is glued to a paper backing. There are many abrasive cloths or papers available in a wide texture range. My own preference is known as garnet paper in both 100 and 120 grit. It has superb cutting qualities and outlasts ordinary sandpaper. If you get the opportunity, try it.

Sandpaper is usually folded in the hand or wrapped around a block of wood. A small sanding block is available commercially or you may wish

to construct your own. A block of wood, shaped to your preference, two saw cuts, a rubber pad, and a coin are all you need.

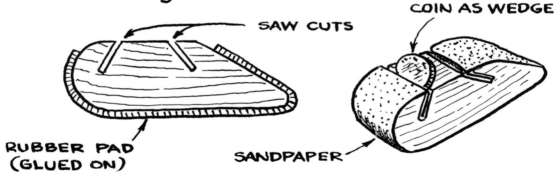

SAW CUTS

COIN AS WEDGE

RUBBER PAD
(GLUED ON)

SANDPAPER

Other useful sanding accessories can be made from scrap wood and dowel sticks. Just wrap a piece of sandpaper around them. Use them to get into those irregular, hard-to-get-at places.

There is no rule on the use of sandpaper. Many whittlers would never sand their finished work. They prefer to let each cut plane, each knife mark, stand out.

Others sand their finished work so smoothly that no knife cuts are visible.

The choice is yours.

One word of caution. If you prefer to sand your work, even a little, save the sanding until after you have completed all the knife work.

Tiny, microscopic particles of the sanding abrasive cling to the wood fibers. They definitely will dull the edge of your sharpest blades and you will discover you have to do continuous resharpening of your blades.

whittling

There are a few basic positions explained here on how to grip a knife. No doubt you will discover others as you progress.

The first grip is used to remove a lot of wood fast. Clench your fist around the knife handle with the back of the knife in the fleshy portion between the thumb and forefinger.

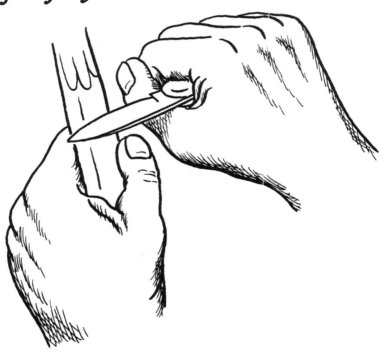

Grip the wood firmly with the other hand in back of the knife. You cut as you push the knife away from you. Cut with the grain of the wood in long,

thin slices. There is very little control on stopping the motion, so be sure the wood is not resting against your knee, or against a good piece of furniture.

The second grip is the one you will find yourself using most of the time. The back of the knife is cradled in the second knuckle of your forefinger. The rest of the fingers curl around the remainder of the handle.

The thumb will be free and is placed on the wood, in front of the cutting edge as an anchor point. Keep the thumb out of line of the blade so the blade will not touch it when cutting. The pressure of the thumb against the wood as you close your fist causes the blade to slice the wood. You will have considerable control of the blade in this manner.

Just be sure to keep your thumb out of the way.

Remember! Your knife is razor sharp and it will cut skin and flesh much easier than it will cut wood. It is up to you to control the blade and direct it away from your fingers and hands.

You can expect to use a few band-aids from time to time. Be sure you don't make a habit of it.

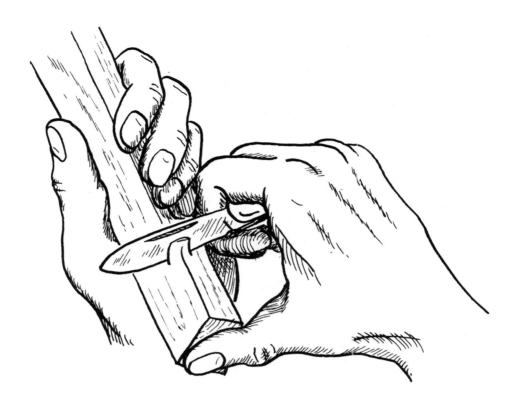

Another position to grip the knife is similar to the second position except the knife blade is reversed. It is now pointing away from you and the thumb is placed on the back of the blade. A variation of this grip is to use the thumb of the other hand to apply pressure by pushing against the tip.

This is illustrated by the sketch on the following page. Considerable control can be exercised in this manner.

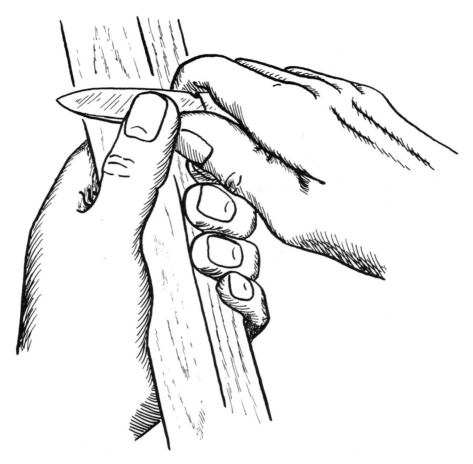

You will find from time to time that by holding the knife as a pencil, you can make the fine cuts that detailing requires.

The forefinger is placed on the back of the blade and the middle finger on the side of the blade toward the tip. The grip is completed by controlling the blade with the thumb placed against the other side of the blade near the handle. The other two fingers provide support against the wood.

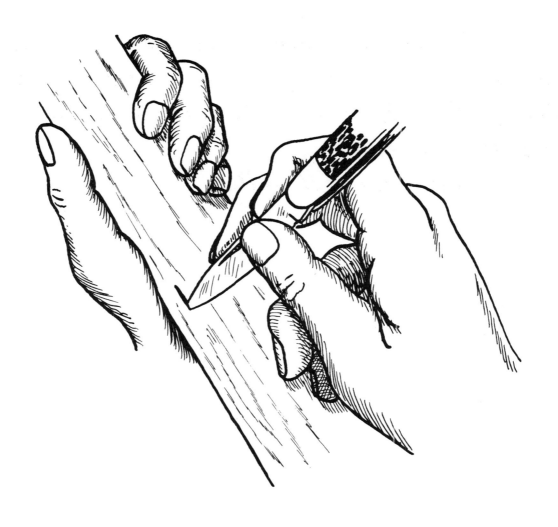

There are other methods as well. You will
discover them as situations arise. Do it the way you
feel comfortable. There is no right way, nor is there
a wrong way, just a safe way that suits you.

Safety is of prime importance!

Remember --- the blade is sharp and will
cut skin with a lot less effort than it will cut wood.

Respect your knife, take care of it, and use caution when placing your fingers near the blade. The knife is not a toy nor something to be played with.

Learn to use it well.

woods

What woods are best for whittling? This is a matter of personal preference.

My preference for a whittling wood is basswood, which is the American variety of the linden tree. The wood is light in weight. It is cream colored and somewhat hard but it carves easily. It does not splinter or split readily. It has no pronounced grain which is a big advantage while whittling. However, this same lack of pronounced grain is a disadvantage I feel in the finished article insomuch that the wood appears lifeless.

I always end up painting basswood with oil paints, watercolors, or acrylics when finished.

Pine is also a good wood. It is commonly available. White pine is prefered over yellow pine which is much harder to carve. A clear coat of varnish or lacquer will bring out the grain and show off the beauty of the wood.

Redwood is another wood that is used by whittlers. I have found that it tends to splinter and split easily. However, using proper care during the

the whittling process and coating with shellac or varnish, the beauty of redwood has a soft and warm glow.

Walnut is a hard wood. It can be whittled but it is slow work. Walnut has a beautiful finish but if you are a beginner, save walnut for a later time.

Experiment with other woods. There are many kinds and each has its own peculiar traits.

You will learn more about woods by trying to work with as many as possible.

If you are like I am you will return to basswood as your favorite, but still work in others from time to time.

projects

A few simple projects will get you off to a good start. Save your more ambitious, complex whittlings for a later date.

Let's start out with some jewelry whittled from a piece of lattice strip.

Lattice strip is smooth on all four sides, commonly pine, and is usually supplied as 1⅜" wide by ¼" thick. It should be available in various lengths at your lumber and building supply company. It is inexpensive and one length will offer many finished pieces.

The first project will be a sailfish pin. Cut a piece of lattice strip about 4¼" long. Trace the pattern on the next page onto the wood.

After the pattern is transfered, the excess must be removed.

EXCESS TO
BE REMOVED

This can be done easily with a jigsaw or a coping saw, but it may also be done using only the knife blade.

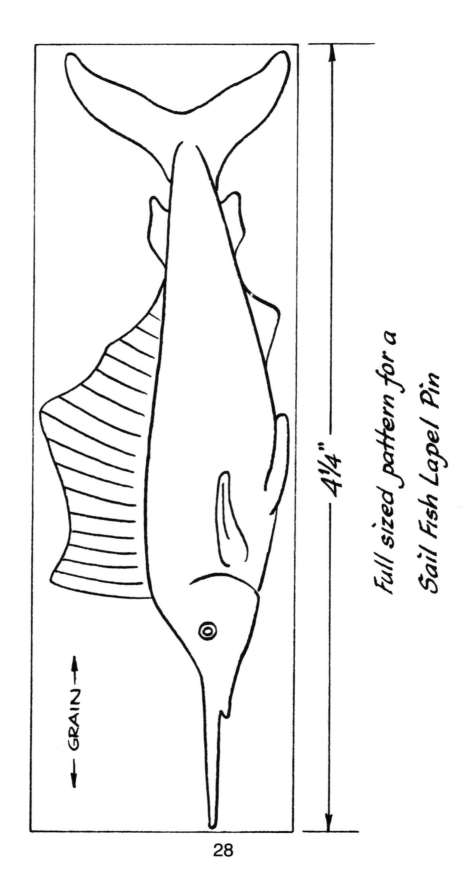

← GRAIN →

4¼"

Full sized pattern for a
Sail Fish Lapel Pin

28

You must strive for a three-dimensional look, somewhat flattened, on this cut-out blank. Do not try to carve or round the edges of the back side.

Taper the fins, tail, and bill:

CROSS-SECTION OF FINS

CROSS-SECTION OF BILL

CROSS-SECTION OF TAIL

Cut "vee" grooves in the dorsal fin:

Notch around the eye and gill:

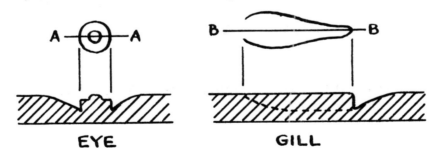

A ——————— A

B ——————————— B

EYE

GILL

Lightly sand the wood until smooth and apply two or three coats of clear nail polish, clear varnish or clear lacquer. Cement a safety catch pin on the back with

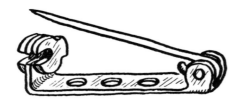

SAFETY CATCH PIN
(AVAILABLE IN HOBBY
AND CRAFT SHOPS)

epoxy cement, allow it to dry and your sailfish pin is completed.

The mushroom pin is worked the same way. Use a length of lattice strip 2½" long. Transfer the pattern outline and remove the excess wood. Start to form the overlapping effect by cutting straight down on the side of the front mushroom, then bevel the other side to it.

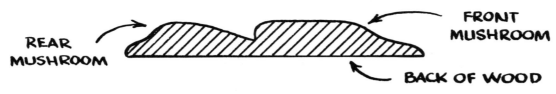

REAR
MUSHROOM

FRONT
MUSHROOM

BACK OF WOOD

CROSS- SECTION VIEW

Use the same basic cut to form the ridges.

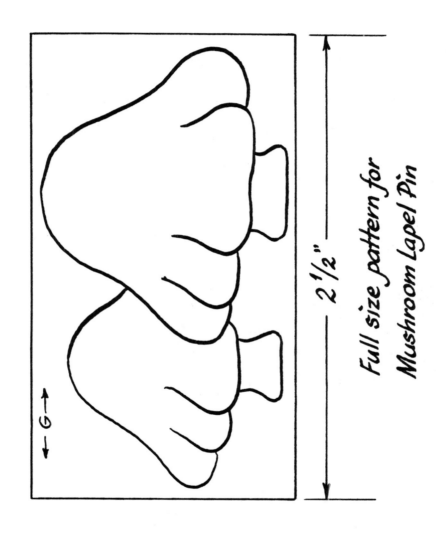

Full size pattern for
Mushroom Lapel Pin

2½"

G

Round off the edges except the bottom

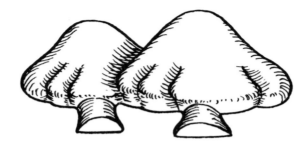

of the stems. Sand to a smooth finish. Cement a safety catch pin to the back or drill a small hole at the balance point, install a "jump" ring, and thread a necklace chain through the ring.

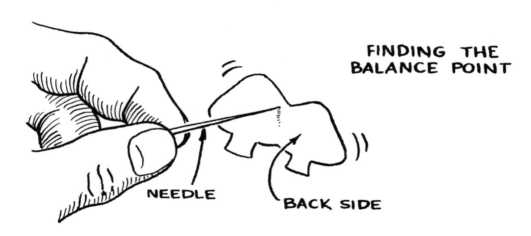

FINDING THE
BALANCE POINT

NEEDLE

BACK SIDE

"JUMP" RING

OPEN

CLOSED

The sailboat can be made into either a pin or a necklace.

Transfer the pattern to the wood. Saw or carve to the outline. Form the sails by cutting deeply, but not through, the areas marked "x".

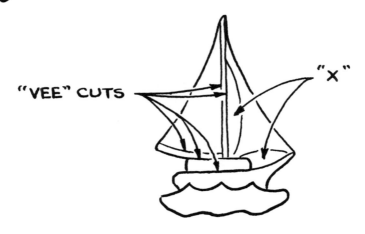

Cut "vee" grooves to outline the cabin, mast, and spar. Taper the hull into the waves.

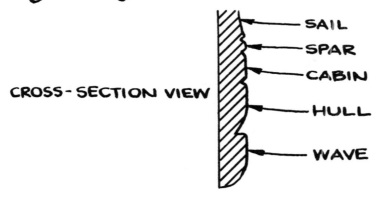

Carve the wave shapes, but use caution. The wood is quite narrow and cross-grained at the edges and can easily split off

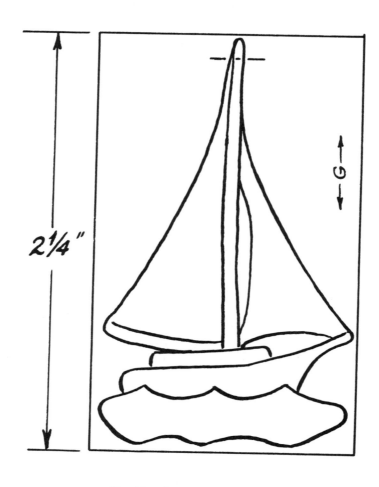

2¼"

G

Full size pattern for
Sailboat Pin or Necklace

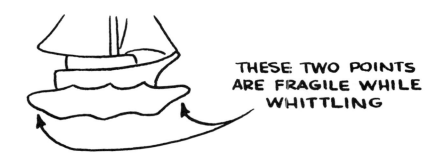

THESE TWO POINTS ARE FRAGILE WHILE WHITTLING

The grain of the wood should receive consideration on any whittling project. Plan your projects so that the thinner sections of the article, whatever it is, run with the grain as much as possible. This practice will lessen the chance of your work splitting in two.

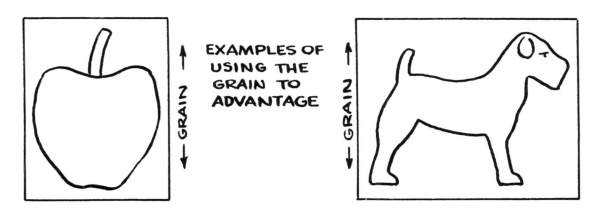

GRAIN

EXAMPLES OF USING THE GRAIN TO ADVANTAGE

GRAIN

Sand your sailboat smooth and cement a safety catch pin on the back side, or if you prefer, drill a small hole through the top of the mast. Install a jump ring and add a necklace chain.

Finish with clear lacquer or varnish to bring out the grain of the wood.

The first three projects would probably be considered as relief carving. The following project is in three dimensions. All surfaces, except the bottom of the base is sculptured.

This is known as whittling-in-the-round. The object can be viewed from any direction as a finished carving.

The same basic methods of whittling will apply for the duck as with any other project.

Secure a block of wood and trim it to a size of 1⅝" x 1½" x 3⅛" high.

This time it will be easier to transfer both front and side view to the block of wood. Start sawing either view to the outline but stop at some wide point, back the saw out, and saw from the other end. This time stop when you are within ¼" of the first saw cut.

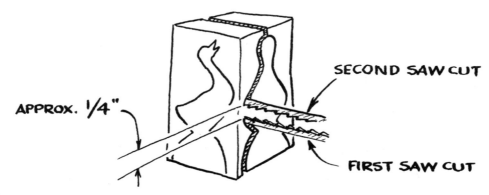

APPROX. ¼"

SECOND SAW CUT

FIRST SAW CUT

Back the saw out and repeat the sequence on the

other part of the same pattern view outline.

Now completely saw out the other pattern outline. Your blank should look like this:

SAW CUTS

All that is left is to cut through the two areas remaining, indicated by "x", to complete your sawed-out blank.

This method of sawing out a blank from a block of wood can be used whenever you have both front and side views. It's a time saver and allows you to get to the whittling sooner. Be sure your saw blade stays to the outside of the outline drawing at all times.

If you are using a jigsaw or a bandsaw you may find the following tip will also work good for you, but be careful of your fingers.

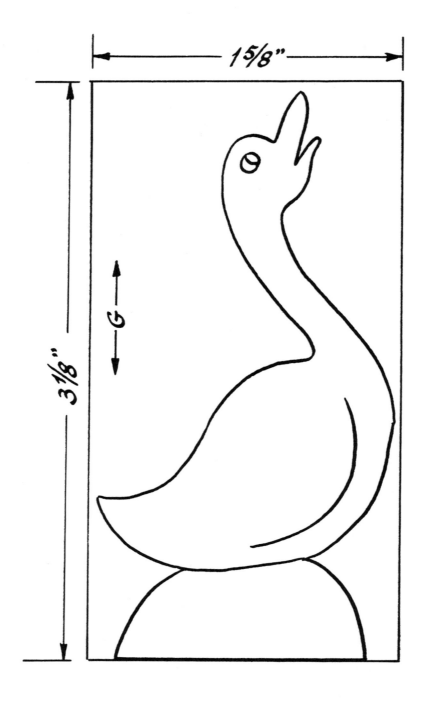

Full size pattern for Duck

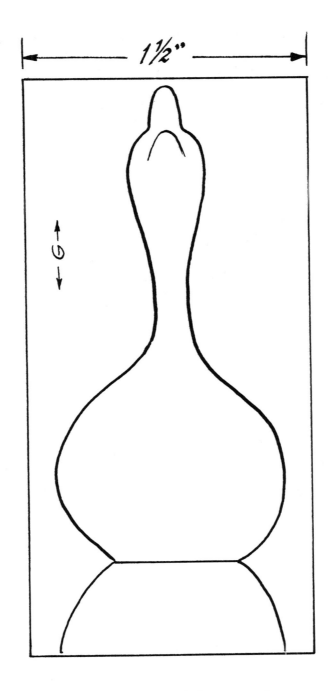

1½"

G

Front view of Duck

You can "square" your block of wood under the saw blade by using the excess wood sawed off from the other view. Use it to block up the blank. Use caution! Your fingers will be very close to the saw blade.

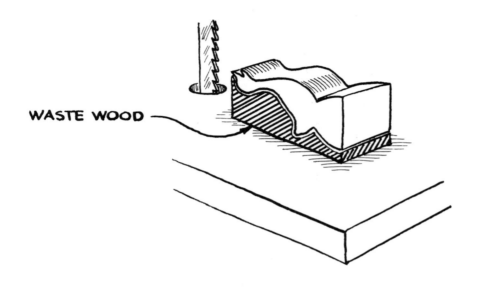

WASTE WOOD

Start whittling the body by rounding the chest and taper to the tail. Shape the neck, head, and bill.

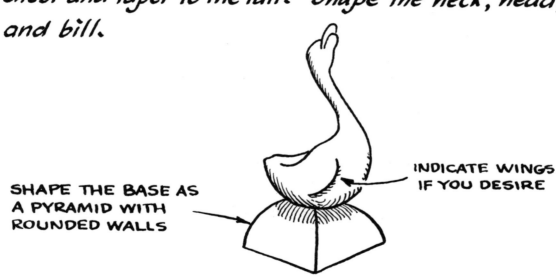

SHAPE THE BASE AS A PYRAMID WITH ROUNDED WALLS

INDICATE WINGS IF YOU DESIRE

The figure of a man is handled the same as the previous project. Follow the same procedures using a block of wood 1½" × 1¼" × 4" long. Transfer the front and side patterns, and saw out the blank.

Use the illustrations as reference.

Roughly carve the entire figure before cutting in the details. This will give you a better idea of the over-all form and allow you to decide on how much detail you wish to show.

DETAIL OF LEG AND FOOT. NOTE CREASE CUTS IN TOP OF SHOE AND CUTOUT TO INDICATE HEEL.

DETAIL OF ARM. ——▶ NOTE WRINKLE CUTS IN "TEE" SHIRT. BE SURE THAT THE HAND LOOKS LIKE IT IS IN THE POCKET.

STUDY THE PLANES OF THE HEAD. TAKE YOUR TIME. DON'T CUT TOO DEEPLY OR REMOVE TOO MUCH WOOD AT ANY ONE TIME. START LOOKING AT HEADS. NOTICE THE NOSE WEDGE, THE EYE SOCKETS, THE ANGLE OF THE BROW, THE CHEEK MUSCLES, ETC.

YOU WILL LEARN TO WHITTLE BY WHITTLING. NOTHING BEATS PRACTICE AND EXPERIENCE.

41

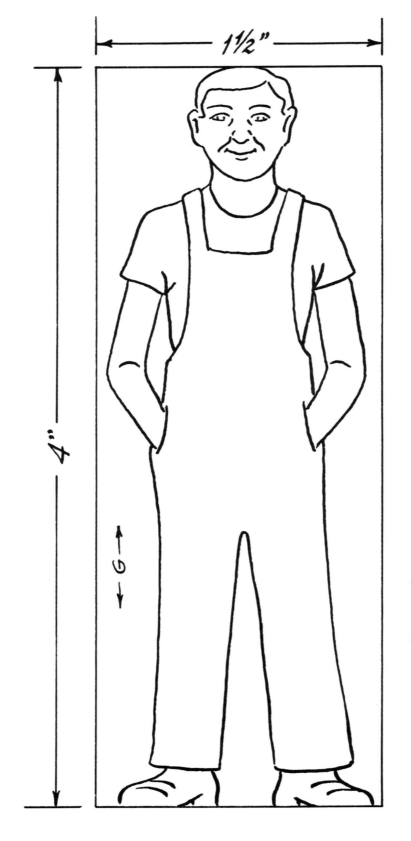

1½"

4"

G

Full size pattern for Figure of a Man

Front View

42

1¼ "

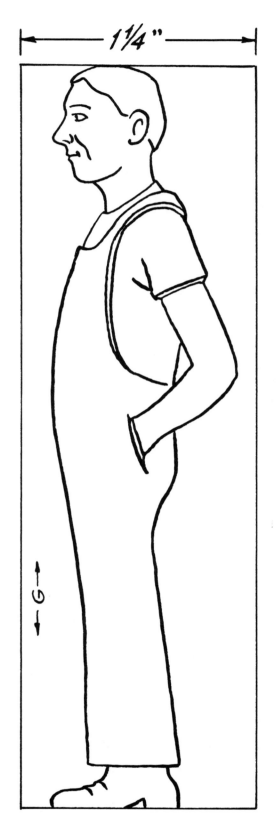

← G →

Full size pattern for Figure of a Man

Side View

43

BUT WHAT DO YOU DO IN YOUR SPARE TIME ?

3-link chain

Perhaps one of the more interesting projects in whittling is the making of a chain. Although the chain is not considered a piece of fine sculpture, non the less it does show the skill of a fine craftsman in the art of whittling.

In this project we will attempt carving only three links. A longer chain can be made by merely repeating the pattern on a longer piece of wood. No doubt that someday you will make a longer, more elaborate chain once you've learned how, so let's get started with the "how".

The 3-link chain is whittled from a block of basswood or pine, 1¼" square by 4" long.

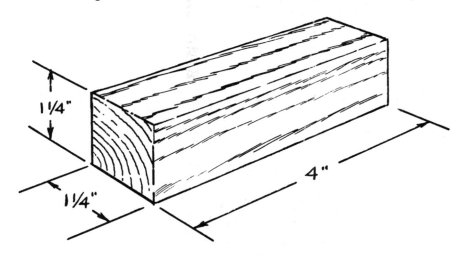

Measure and mark the following dimensions on all sides of the block.

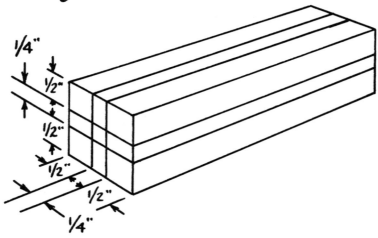

The areas indicated by shading must be cut away.

Begin by shaving away the four corners until your block looks somewhat like this.

Now run your knife blade down the lines, but don't force the blade too deep. Carefully cut slivers

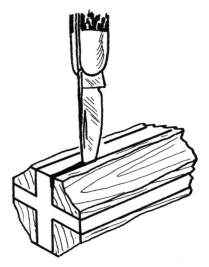

of wood away, a little at a time, until a shaded area is completely cut out. Cutting too deeply all at once may split the wood. Take your time.

When one corner is done, go to the next, etc., until your block of wood looks like a long cross.

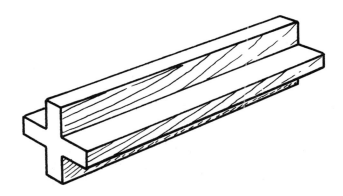

It is on this shape that you will draw the

outline of the chain links. You will have to transfer the measurements of the patterns to the wood carefully. Use the drawings on the next page.

You can double check your drawing by comparing it to this sketch.

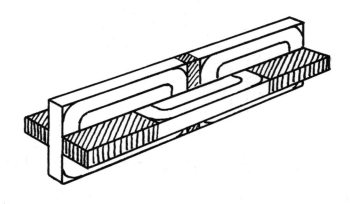

Again, the shaded areas are to be whittled out next.

You can now see the links taking shape.

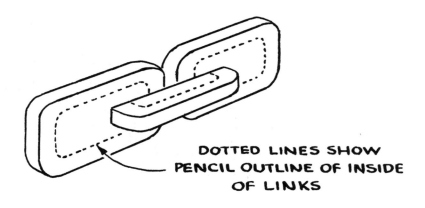

DOTTED LINES SHOW
PENCIL OUTLINE OF INSIDE
OF LINKS

Continue your whittling by carving the inside

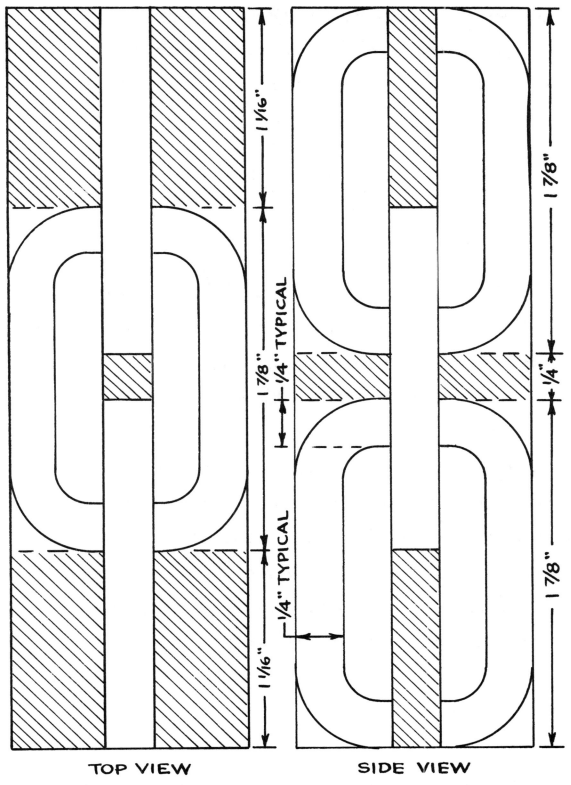

1 1/16"

1 7/8"

1/4" TYPICAL

1 7/8"

1/4" TYPICAL

1 1/16"

1 7/8"

1/4"

1 7/8"

TOP VIEW

SIDE VIEW

FULL SIZE PATTERN FOR 3-LINK CHAIN

49

of the links by following the pencil marks.

You are now ready to separate the links. The three areas marked "x" are to be carefully cut away.

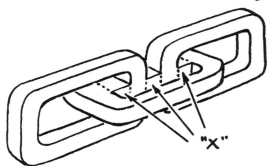

"X"

You are working across the grain so take your time. Once the links are free, start rounding them until they are smooth. Sand lightly, if you wish.

Congratulations! You've completed your 3-link chain.

By repeating the procedures and the patterns you can make any length chain you wish. By changing the dimensions proportionately, you can make smaller or larger links. You have mastered the fundamentals.

Often, a length of chain is displayed with a ball-in-cage on either or both ends.

ball-in-cage

The Ball-in-Cage is a favorite of many whittlers. There are many variations of this theme, including a ball-within-a-ball, within-a-ball,--etc. These varieties can be quite complex in design and in execution. The project presented here is in it's simplest form and will afford you many hours of fun.

People will ask, "How did you get the ball inside the cage?" The answer is of course that the ball was never outside of the cage.

Start by cutting a block of basswood, or similar carving wood, to the size shown.

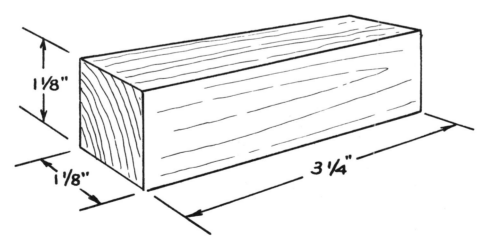

When you have finished cutting the block, and the sides are square and smooth, transfer the following pattern to the four sides of the wood.

Be sure to make the four patterns uniform and of the same dimensions.

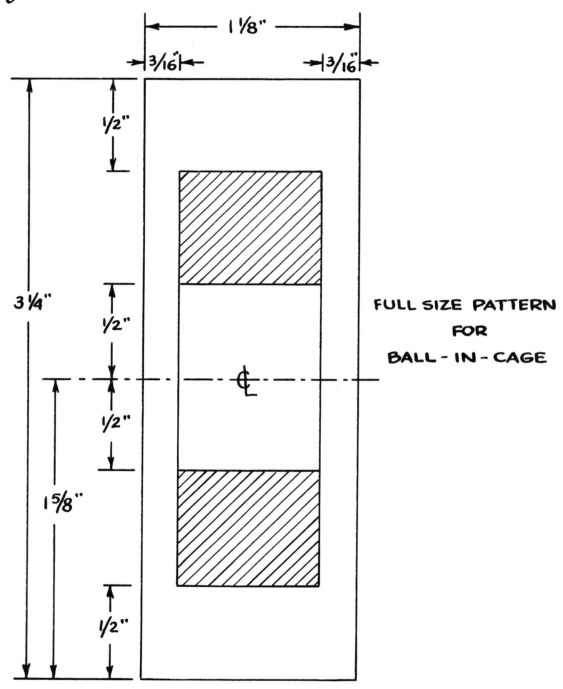

FULL SIZE PATTERN
FOR
BALL - IN - CAGE

The shaded area shown on the full-size drawing is to be removed. If you want to save time, you can remove the waste wood, (the shaded area), by drilling through the block.

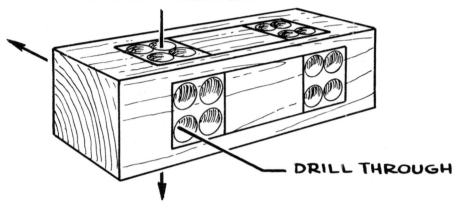

DRILL THROUGH

DRILL THROUGH

Finish removing the excess wood with your knife. Take care not to cut into the corner rails.
You can use only your knife to get the same results, although just a little slower. It's up to you.
When you've carved out the shaded areas your block should look like this.

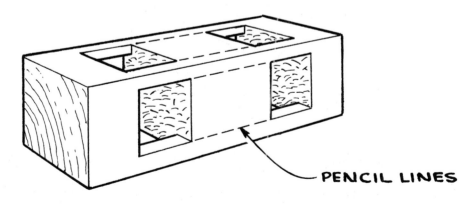

PENCIL LINES

The center portion of the block will become the ball and is started by making bevel cuts along the four corner rails. This is done by scoring a cut along the pattern line as shown in "A", then carefully cut a strip out, "B", on all sides

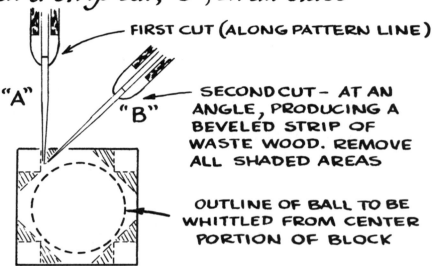

FIRST CUT (ALONG PATTERN LINE)

"A"

"B"

SECOND CUT – AT AN ANGLE, PRODUCING A BEVELED STRIP OF WASTE WOOD. REMOVE ALL SHADED AREAS

OUTLINE OF BALL TO BE WHITTLED FROM CENTER PORTION OF BLOCK

With all the bevel strips removed, the center should appear like this.

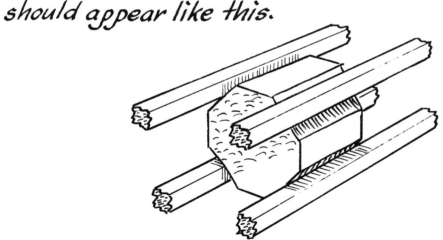

The next step is to cut the ball to shape and to free it from the four corner rails. Study this next

illustration. It is the key to a successful ball-in-a-cage.

FULL SIZE CROSS-SECTION THROUGH CENTER OF BLOCK

Notice that the ball is slightly smaller than the outside dimension of the wood and that it larger than the space between any two adjacent corner rails.

To carve the ball into a perfect sphere, one that will roll freely from end to end without falling out, may tax your patience a bit. Shave away small chips of wood, continuously checking for roundness.

The corner rails must stay straight with no bows.

Take your time, don't hurry. No doubt you will lightly use sandpaper to smooth the ball once you've finished whittling. Keep checking the shape of the ball for roundness.

Your finished Ball-in-Cage should now look like this.

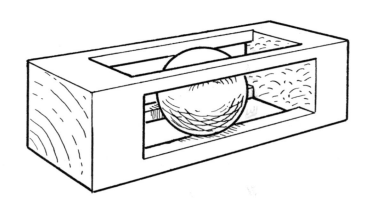

swivels & slip-joints

Slip-joints and swivels are normal additions to a more elaborate length of chain or a ball-in-cage.

A slip-joint is one where two pieces of wood slide back and forth but are captive to each other. This is a typical slip-joint.

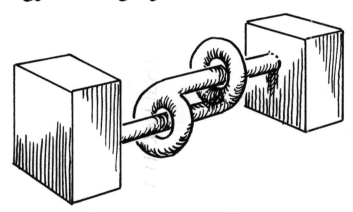

Both pieces are free to move within each other.

The illustrations for this project are just for the slip-joint by itself. If you wish to make this a part of a chain length be sure to allow enough extra wood on the ends so you can whittle the fixed connecting links.

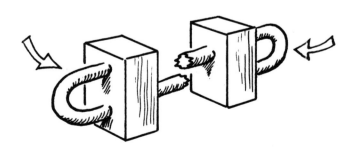

Start with a block of wood 7/8" by 1 3/16" by 3" long.

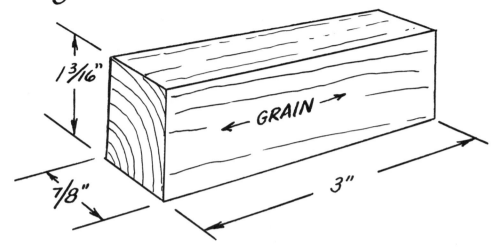

Lay out the top view pattern as shown on the next page.

As this view is quite simple you could use saw cuts to speed up the whittling process if you so wish.

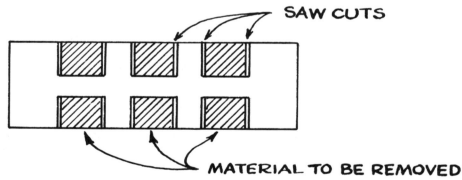

If you object to the use of a saw, use your knife to make the necessary cuts. In either case, use care that you don't cut too deep nor split the wood of the cross-grained "rings".

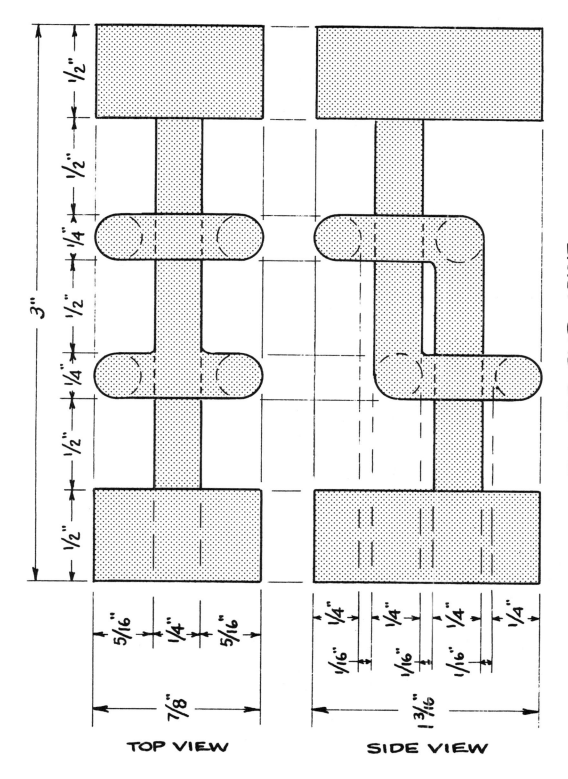

FULL SIZE PATTERN FOR SLIP-JOINT

TOP VIEW

SIDE VIEW

After this first step your block should now look like this.

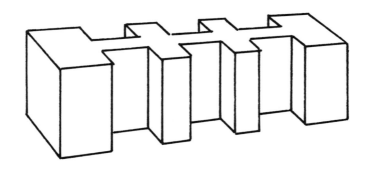

Now mark off the side view on the block. After cutting away the excess, you should have this shape.

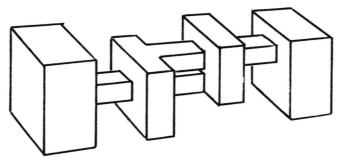

Keep in mind that the two rings are circular, and that the shafts come off the sides of the rings at right angles.

Both the rings and the shafts will be rounded and must fit freely in one another.

Whittle the wood carefully. Do not try to take

off too much wood at any one cut. Small thin slices will remove the wood just as quickly with a lot less chance of splitting. It also allows you to observe the shape of the article as you progress so you can make the necessary corrections.

Whittling the center of the rings, where the shafts go through will be a little delicate, but with patience and caution your block of wood will separate into two parts.

Finish up by carefully sanding all surfaces smooth.

The next project will be the swivel joint.

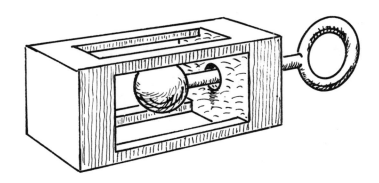

A swivel is a moveable joint which will allow rotation, yet does not separate.

This project resembles the ball-in-cage with a few changes.

First, you will need a piece of wood cut to the size shown. Again, my favorite whittling wood is basswood, but you may choose others. A nice piece of white pine is a very good choice.

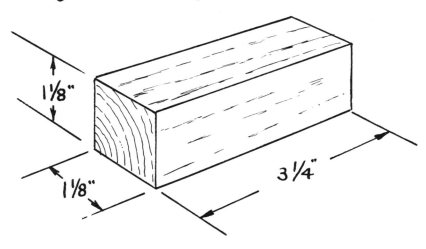

1⅛"

1⅛"

3¼"

If you intend to make this a part of your chain be sure to allow an increase in the length dimension to give you enough wood for the fixed link.

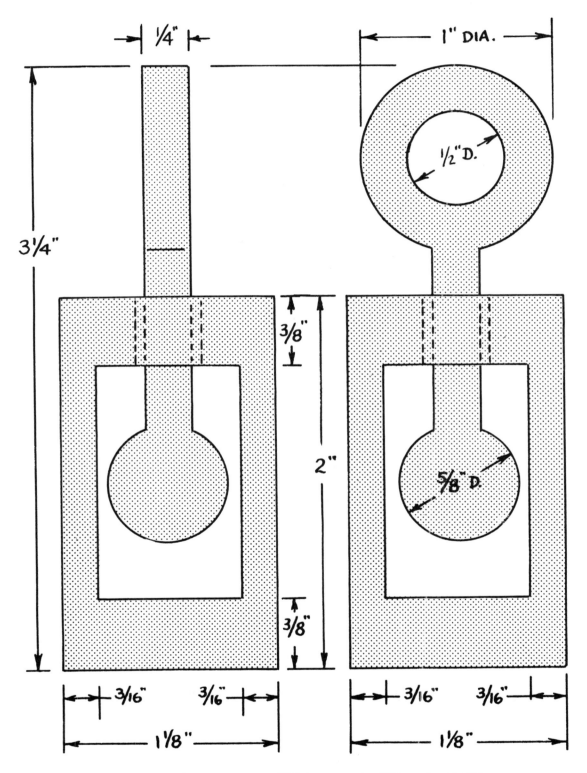

¼"

1" DIA.

½"D.

3¼"

3/8"

2"

5/8" D.

3/8"

3/16" 3/16"

3/16" 3/16"

1⅛"

1⅛"

FULL SIZE PATTERN FOR SWIVEL JOINT

Layout the top view on your block and cut away the excess.

Now lay out the side view, and remove the excess from the block.

Whittle the block as you did the ball-in-cage, except that you make the ball smaller in diameter, and be sure to leave the wood for the shaft that will run through the center of the end piece. This shaft will be about 1/4" in diameter.

Round the shaft on both sides of the end piece, and round up the link.

Rough carve the ball to its approximate shape. You can finish it later when the shaft is free.

Use the sharp point of your knife to cut the shaft loose. Work carefully. Don't dig in at an angle or you will slice the shaft.

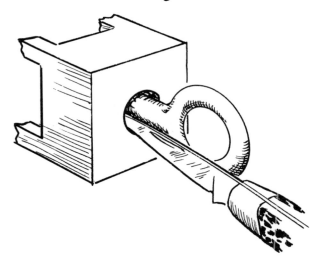

Keep your knife point parallel to the shaft. Try to make the opening between the shaft and the end piece as narrow as possible. This will require a little patience and care.

Once you have cut through, you will find it easier to round the shaft evenly by moving it back and forth as you make your cuts. It is also easier

at this time to form the ball into a smooth sphere.

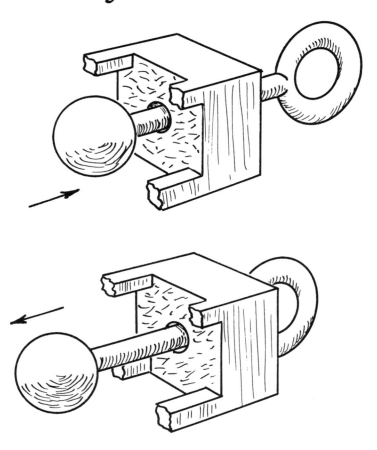

Sand smooth, and you have now completed
your swivel joint. This is the basic principle and
other shapes may come to your mind. Go to it. You
can whittle many interesting combinations using
the basic ideas of the chain, the ball-in-cage, the
slip-joint and the swivel joint.

chain variations

I have mentioned in previous chapters, the making of more elaborate chains. These few sketches and ideas will start you on some ideas of your own.

First, the link itself. There is no reason why a chain link should be whittled only one way. Instead of the popular design illustrated, make your chain links different. Circular links are one variation.

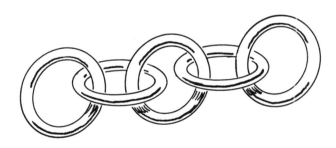

The methods of laying out a pattern, and of whittling the links are the same. Just the dimensions will change.

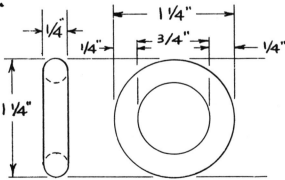

½ SIZE ILLUSTRATION OF A CIRCULAR LINK

Draw your own pattern on paper, similar to this sketch.

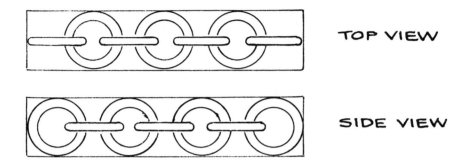

TOP VIEW

SIDE VIEW

You can use your own dimensions or use the measurements on the preceding page. When your pattern is finished, transfer it to a suitably sized block of wood.

You may wish to try a more difficult design, known as the twisted link.

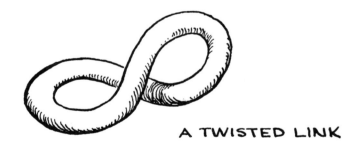

A TWISTED LINK

In this design, imagine you have an elongated link. Grab the ends with two pairs of pliers, and twist one end so it is at 90° or at a right angle to the first half.

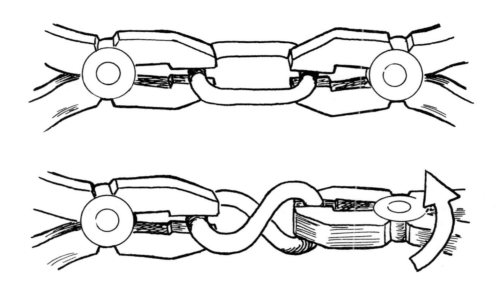

Whittling this type of link is more difficult but the effect is attractive. The layout is a little tricky so take your time.

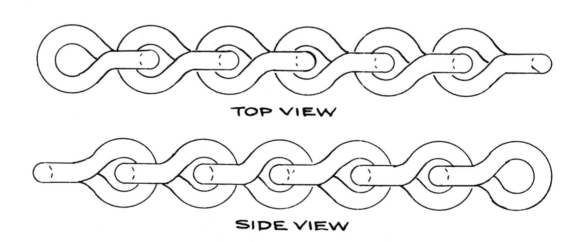

TOP VIEW

SIDE VIEW

Another link design is one I call the double link. Actually, it is the same as the one you learned in the "3-link chain" except for an attached center bar.

The pattern would look like this.

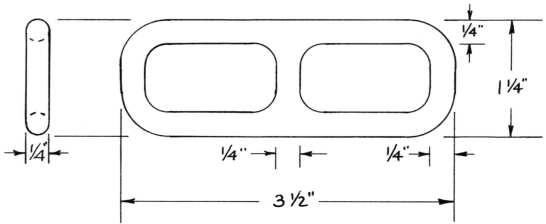

¼"

1 ¼"

¼"

¼"

¼"

¼"

3 ½"

You can make the link any size you would like to. I've notated dimensions that will keep it to the same size as the links in the "3-link chain".

Another interesting project is to whittle out two end plates connected by 3 lengths of chain, all from one piece of wood.

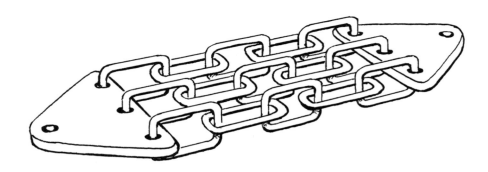

This is somewhat of an ambitious project,

and can be made as an individual piece, or as part of a longer chain.

The layout for each of the three lengths of chain is similar to the "3-link chain" pattern except that each length has two additional links.

The end plates are simple in appearance but the whittling of the holes with the links in them is a little tedious and will take time. Again, don't try to rush,

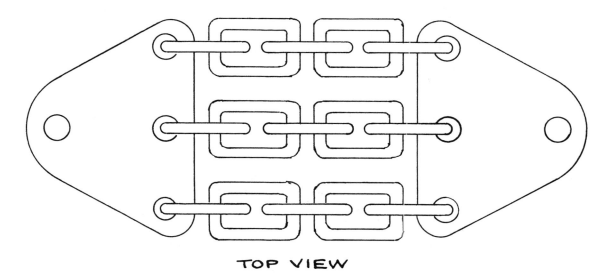

TOP VIEW

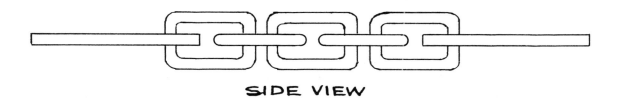

SIDE VIEW

take your time. You will be proud of the finished item for it shows considerable patience and craftsmanship.

If you make the links the same as shown in the pattern for the "3-link chain", you will need a board measuring 1¼" by 4¾" by 11 ¾" long. Links smaller or larger will require either a smaller or larger piece of wood. Lay out your pattern carefully on a sheet of paper using the drawing on the previous page as a guide.

Here is another chain variation. Instead of the straight length of chain, you can make a continuous or endless chain. You will need a wider board for this project than that required for a straight chain.

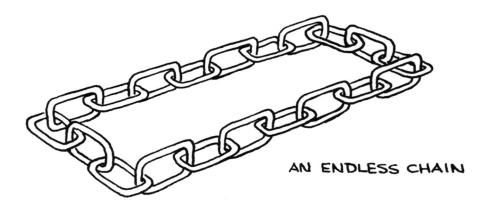

AN ENDLESS CHAIN

The links on the end will be fragile because the grain of the wood runs across the entire link and a little more care will have to be used to keep them from breaking off.

As the desired size of the finished chain will vary from reader to reader, only a general layout is illustrated. Adjust the dimensions to suit yourself. Use the "3-link chain" proportions as reference.

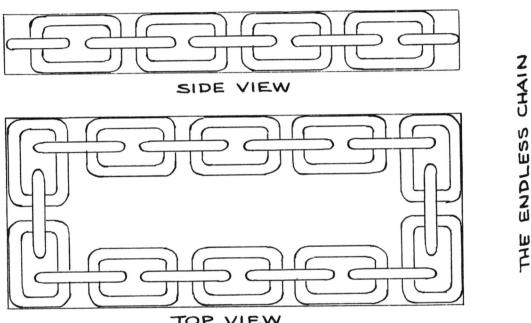

SIDE VIEW

TOP VIEW

THE ENDLESS CHAIN

Of course you can include as many links as you wish in the length, but do not exceed the three shown in the width of the board.

I've used the phrase, "a more elaborate chain", in the foregoing text. The following sketches portray what I have in mind. Use them as whittling projects or use them

as a start of some of your own sketches. Notice the lower ends. This will give you some ideas on finishing off your chains.

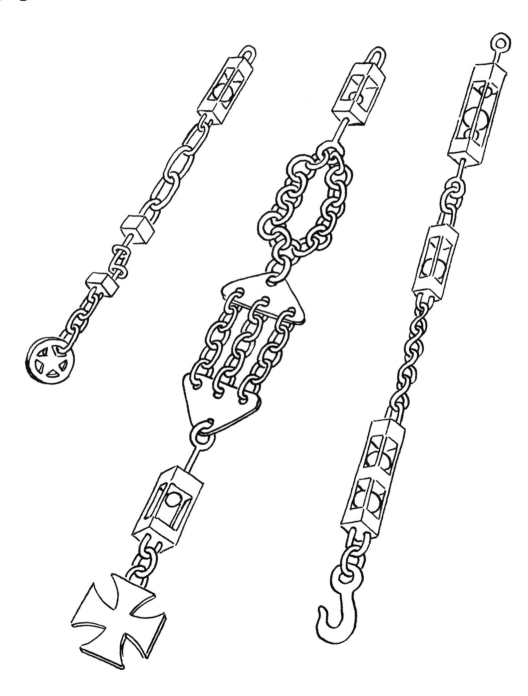

folding knife

Using a pocket knife to whittle a pocket knife is an interesting project. Let's start out by making a simple one-blade knife.

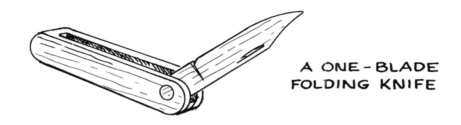

A ONE-BLADE
FOLDING KNIFE

Once you've mastered the basic idea you may wish to copy in wood, your favorite pocket knife, or perhaps make a two or three blade knife.

This is one of those projects that's easier to do, than to explain. The explanation may be overdone, but rather that, than to leave it unclear.

To begin, saw out a block of basswood or white pine to the following dimensions.

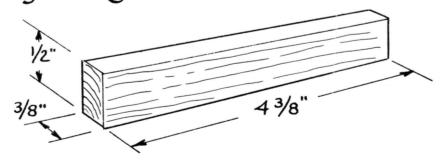

1/2"

3/8"

4 3/8"

Carefully transfer the top and side view outlines of the full-size pattern to the block of wood.　○—→

Shape the wood by whittling thin slices away until you are satisfied with the overall form. Pay attention to the grain of the wood in the blade area. Trying to remove too much wood at any one time may cause the grain to run off and split across the blade, ruining your project.

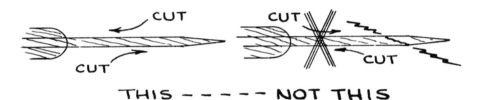

CUT CUT

CUT CUT

THIS — — — — — NOT THIS

The center portion of the handle must be hollowed out. In most cases, your pocket knife blade is too large to successfully cut this area out.

An X-acto knife, or similar tool with replaceable blades, can handle this part of the job. You can modify the #17 chisel-shaped blade for the task.

1/4" #17 CHISEL-SHAPE BLADE

1/8" #17, MODIFIED

REMOVE SHADED AREA

When using a power grindstone, belt-sander or

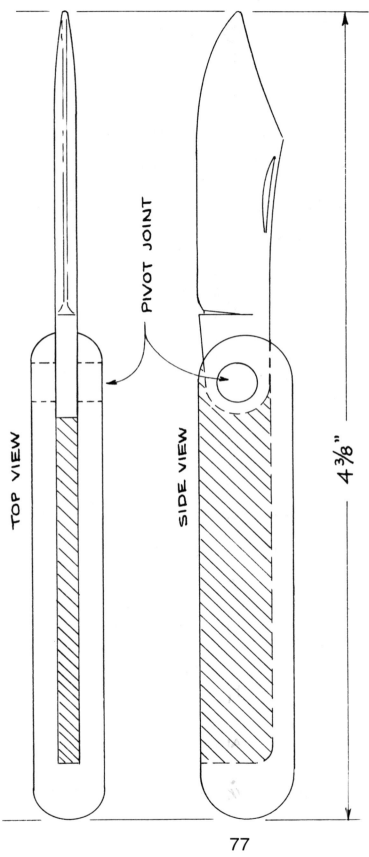

TOP VIEW

SIDE VIEW

PIVOT JOINT

4 3/8"

FULL SIZE PATTERN FOR FOLDING KNIFE

(SHADED AREA TO BE HOLLOWED OUT)

or disc sander, you will have to be careful not to overheat the blade. Overheating will take the temper out of the steel and it will become too soft to hold an edge.

Remove the shaded portion as shown, leaving a 1/8" chisel. You can now use this chisel blade to make the end cuts, and your pocket knife blade to make the side cuts of the hollowed out area.

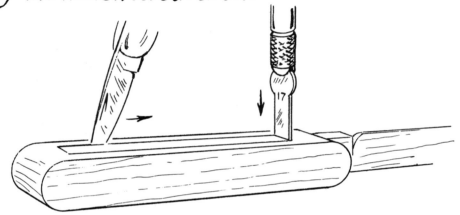

Use the chisel blade to smooth out the bottom. You must undercut the small area marked "X" and round off the area marked "Y".

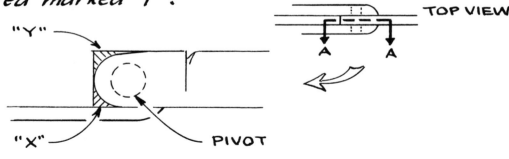

"Y"

TOP VIEW

A A

"X" PIVOT

SECTION THRU A-A

You are now ready to make the pivot which will

allow the blade to fold into the handle. This is the most important step in whittling this project.

Begin by cutting straight down around the outside of the circle. Do this on both sides. Be sure you cut deep enough.

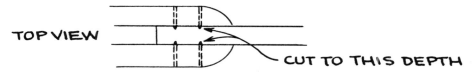

TOP VIEW

CUT TO THIS DEPTH

With a real thin blade start to slice through to the pivot joint. To help you realize the effect you are trying to obtain, imagine the wood separated into two pieces; the handle, and the blade. They would look like this:

— NOTE —

THE PIVOT JOINT MUST BE PERFECTLY ROUND AND IN THE SAME POSITION ON EACH SIDE OR THE BLADE WILL BIND WHEN CLOSING, BREAKING THE JOINT.

The back spring of the handle must be cut in also in order to free the blade. Use the 1/8" chisel-blade and your pocket knife. The following sketches will clear up some of the questions you may have.

CROSS SECTION VIEW SHOWING
BLADE (SHADED AREA) AND HANDLE

UNDERSIDE VIEW SHOWING
BACK SPRING CUTS

CROSS SECTION VIEW SHOWING
BACK SPRING CUT (BLADE
SHOWN AS DOTTED LINE)

INTERNAL VIEW OF
BACK SPRING
AND BLADE

When all the cuts have been properly made, grasp the handle in one hand, and the blade in the other. Gently, but firmly, try to move the blade. If you meet with resistance — STOP!

Go over the cuts again, especially around the pivot circle, and free the part or parts that have not

80

been cut through. Try the closing action again. You may have to repeat some of the cuts again but eventually the blade will free itself.

Now carefully shave away any areas of the wood that interferes with the smooth opening and closing of the blade.

Sand smooth, if you wish, and wipe away the perspiration from your brow. You've succeeded in whittling out a folding knife from one piece of wood.

For those of you who may wish to whittle a copy of a knife that has two blades on one end, study the following sketch.

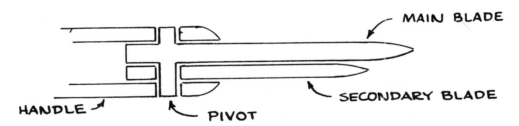

The knife is whittled the same as before, except the pivot is longer on the one side. The second blade is loose around this longer pivot. A great deal of care should be taken to keep the pivot from splitting off. Work slowly and don't try to hurry.

The pieces, if separated, would look like this.

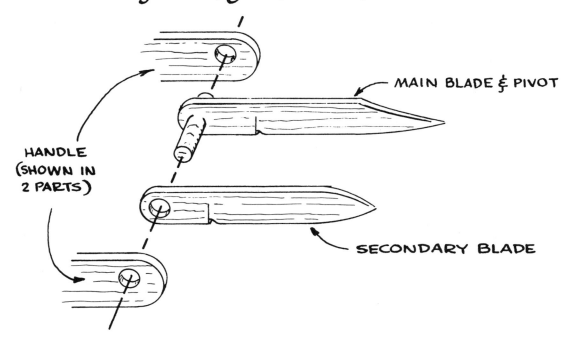

HANDLE
(SHOWN IN
2 PARTS)

MAIN BLADE & PIVOT

SECONDARY BLADE

The back spring will be the width of both blades, and of course the handle will have to be wider in order to accomodate both blades.

I hope you have enjoyed making these projects as much as I have enjoyed writing and illustrating them.

THE CRITICS

anatomy of a fish

Before we rush off and get that block of wood and that pocket-knife it would be wise to know a little something about our subject matter. We do not have the need to become too technical nor to make detailed biological studies. As a whittler, we should learn the names and locations of the external parts.

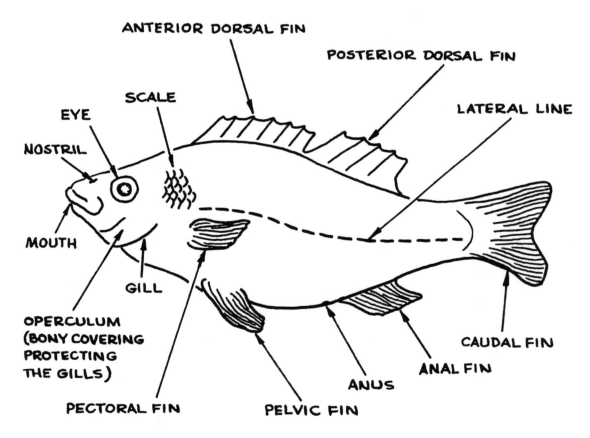

ANTERIOR DORSAL FIN

POSTERIOR DORSAL FIN

LATERAL LINE

SCALE

EYE

NOSTRIL

MOUTH

GILL

OPERCULUM
(BONY COVERING
PROTECTING
THE GILLS)

PECTORAL FIN

PELVIC FIN

ANUS

ANAL FIN

CAUDAL FIN

At a later date, when you are ready to advance to the more complex carving of the fish in action, you

must remember that the body has a skeleton, made up of a series of vertebrae which makes it flexible. The membrane of the various fins are also flexible and can twist and curve.

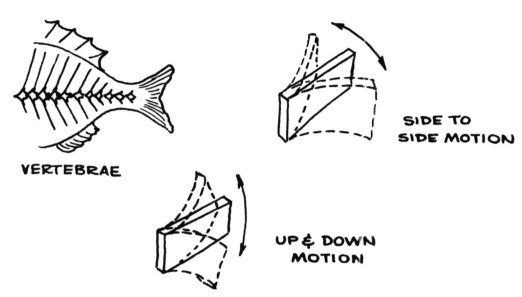

VERTEBRAE

SIDE TO SIDE MOTION

UP & DOWN MOTION

Naturally these action poses would make for a more interesting model but the carving detail is beyond the simplified explanations found in this book.

I would suggest that you study photographs or watch, with special attention, some of the underwater nature films. Be alert to the twisting and flexing motion of the fish in it's own world. Remember these actions and incorporate them into your own carvings when you are ready.

whittling procedures

Most fish have the same basic parts as shown in the preceding anatomy sketch, although these parts may vary in size, shape, and location.

Whether you are whittling a Bluegill, Channel Bass, or any other species, the whittling procedures would be the same. These steps will be described for fish in general, no specific species in mind.

First of all you should decide on the particular fish you wish to whittle. You can use the patterns in the back of this booklet or you can draw your own, using a book or magazine photo as reference.

(You can enlarge or reduce any pattern to the size you want by using the "grid system". In the

86

event you are not familiar with the "grid system" refer to page 118.

Trace the outline of your fish onto a sheet of tracing paper. (This step keeps you from defacing your reference photo or pattern.) Transfer your outline tracing to a block of your favorite whittling wood by placing a sheet of carbon paper under your drawing and go over the outline with a pencil.

Using a band-saw or an electric jig-saw, cut out the fish blank by following the outline. A coping saw will do the same work by hand but it will just be a little slower. Your blank should now resemble this sketch.

Next, we want to rough out the various fin areas. Pencil a centerline all the way around the blank.

PENCIL IN
CENTERLINE
ALL AROUND
THE BLANK

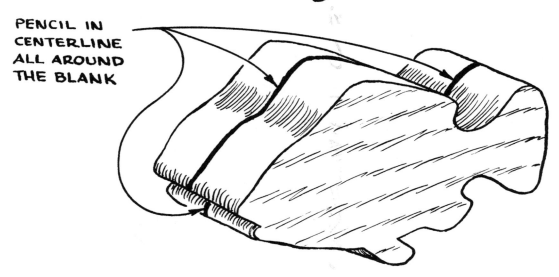

We will start whittling the dorsal fin, but first, pencil in the width of this fin. Also mark the curved line representing the top of the body on the side view.

MARK WIDTH
OF DORSAL FIN

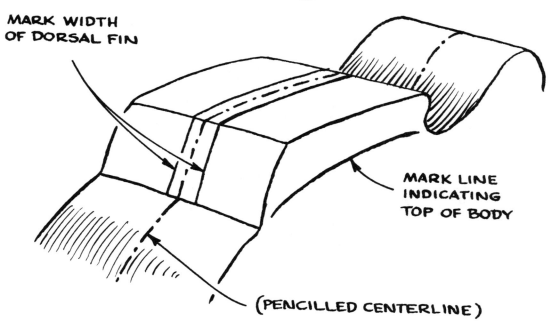

MARK LINE
INDICATING
TOP OF BODY

(PENCILLED CENTERLINE)

Cut down into the line representing the top of the fish, then make a bevel cut and remove the excess. Continue these steps until you arrive at the pencil mark indicating the width of the dorsal fin.

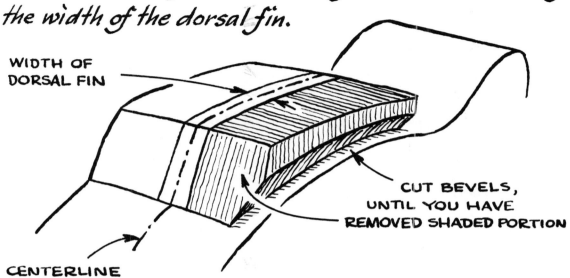

WIDTH OF
DORSAL FIN

CUT BEVELS,
UNTIL YOU HAVE
REMOVED SHADED PORTION

CENTERLINE

Repeat this procedure on the other side. Your roughed-in fin should now look like this.

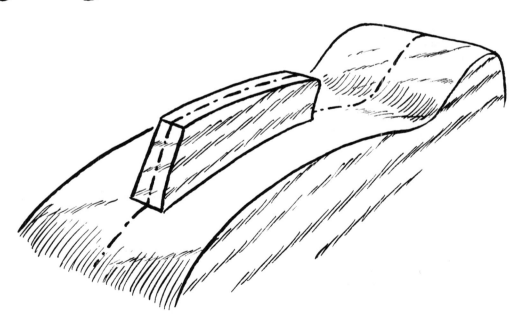

Don't start rounding off yet. It is better to remove all the major waste areas first by roughing-in the rest of the fins.

The tail fin or caudal fin will be roughed in next. Again, indicate the thickness of the fin with your pencil and draw in the body line. Note that this is a tear-drop shape. It will eventually be rounded to taper and flow gracefully into the tail. Remove the excess wood on both sides as before, leaving your blank looking like this.

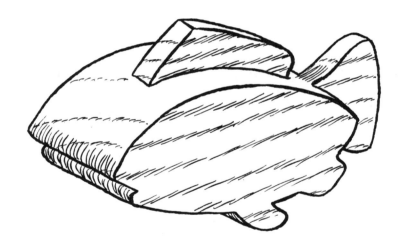

The anal fin underneath will be treated the same way. Indicate the thickness and whittle down to this line on both sides.

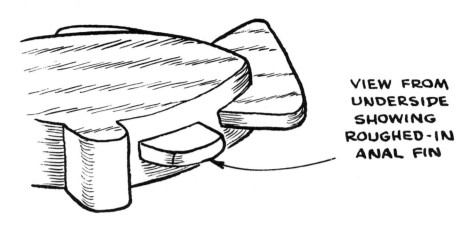

VIEW FROM
UNDERSIDE
SHOWING
ROUGHED-IN
ANAL FIN

The next step will be to rough-in the pelvic fins. These two fins project downward and outward from the body. Cut a series of "vee" notches until you have two distinct shapes with a flat space between them.

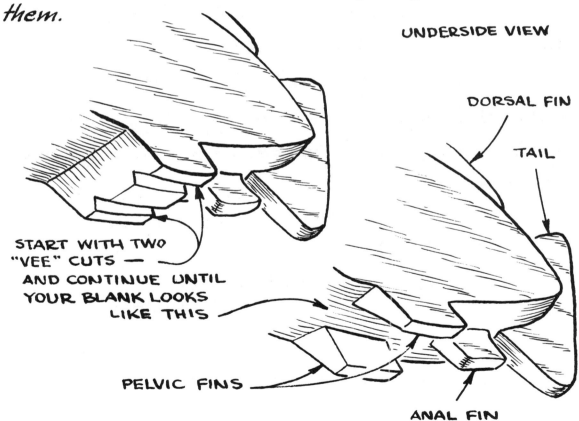

UNDERSIDE VIEW

DORSAL FIN

TAIL

START WITH TWO
"VEE" CUTS —
AND CONTINUE UNTIL
YOUR BLANK LOOKS
LIKE THIS

PELVIC FINS

ANAL FIN

Mark the start of the pelvic fins, with a pencil, on the side view. Notch on these lines. We'll shape them later.

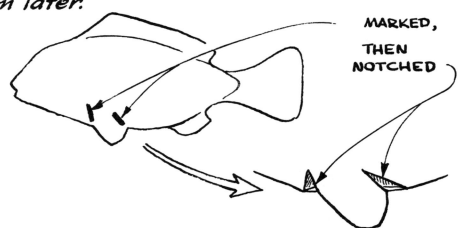

MARKED, THEN NOTCHED

Draw the outlines of the pectoral fins on the sides of the body. Take your time when locating these lines. The right side of the fish must match the left side, so watch the size and direction carefully.

The pectoral fins will be fairly flat, lying against the side of the body. Indicate them by making a vertical "stop" cut along the fin line and then make a long bevel cut into the stop cut.

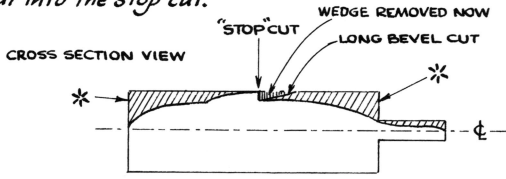

CROSS SECTION VIEW

"STOP" CUT

WEDGE REMOVED NOW

LONG BEVEL CUT

℄

✳ - SHADED AREA WILL BE REMOVED LATER

92

Indicate, with circles, where the eyes will be.
Be sure the marks line up on both sides of the body or you
will end up with a cock-eyed fish. Recheck the up and
down location and recheck the front-to-rear location. Be
sure the circles are the same size.

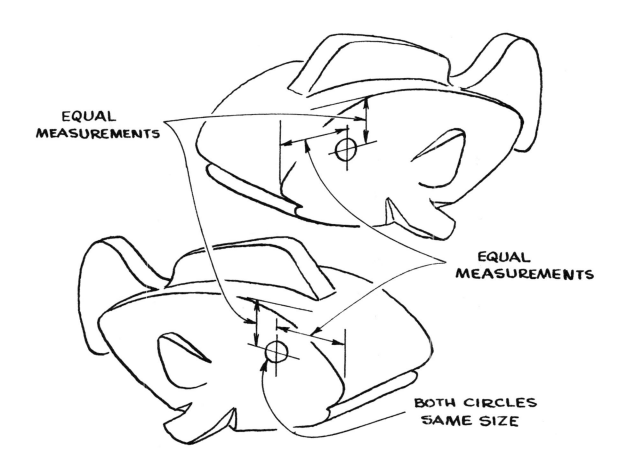

Cut down into these circle lines and remove
the excess wood on the outside with a bevel cut.
Refer to the next drawing to understand this
procedure better.

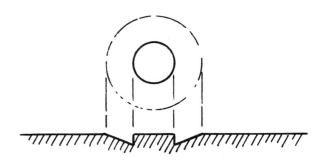

We can now start shaping the body. The body will be basically thin and flat, sloping easily into the fins.

Don't concentrate on only one section of the fish. Let the overall shape evolve little by little as you cut away the wood from one side, then the other, from the head to the tail and back again to the head.

As the shape gradually forms you can readily see the parts that need a little more whittling.

The beauty of the fish is the easy-flowing, streamlined shape.

Remember the downward and outward direction of the pelvic fins as the body curves underneath.

CROSS-SECTION SLICE

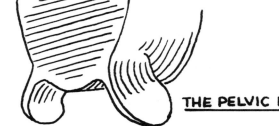

THE PELVIC FINS

You've already indicated the basic form of the pectoral fins. Now gently curve the forward edge into the gill depression.

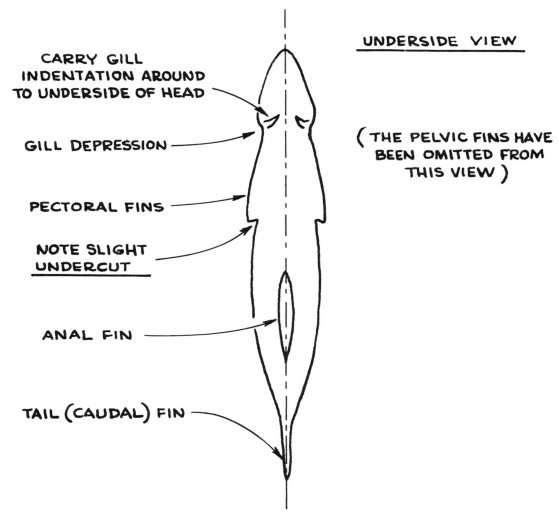

CARRY GILL INDENTATION AROUND TO UNDERSIDE OF HEAD

GILL DEPRESSION

PECTORAL FINS

NOTE SLIGHT UNDERCUT

ANAL FIN

TAIL (CAUDAL) FIN

UNDERSIDE VIEW

(THE PELVIC FINS HAVE BEEN OMITTED FROM THIS VIEW)

Gently taper the body into the pectoral fins and slightly undercut the trailing edge of these fins to give the appearance of protruding out from the body.
Notch the gill lines and taper the body, sloping into these notches.

Some fish have ridges that resemble lips, and they should be indicated, especially at the corners of the mouth.

A shallow knife cut to indicate the location of the lips and a thin shaving tapering into this cut should be ample to show the upper lip.

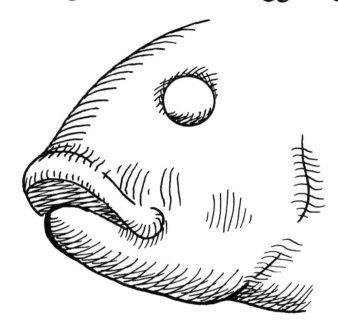

The corners of the mouth would have a deeper cut, rounding over the top to the side of the head. The lower jaw is to be whittled to allow for the "overbite" when the lower jaw closes underneath the upper jaw.

The eyes will be finished next. The eyes of the fish are indicated as two flat domes,

one on either side of the head. The wood around
them is whittled away so these domes will actually
be above the surface. Caution! A great deal of care
must be taken so as not to gouge or slice into them
as the body is being formed.

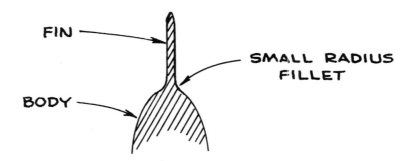

The dorsal and anal fins are thin. The point
where they join the main body is not a sharp angle
but rather a small radius fillet.

FIN →

SMALL RADIUS
FILLET

BODY →

When you were blocking in the primary areas
of the fish, a wedge or triangle shape was left where
the body joins the tail, or caudal fin.
This area of wood must now be whittled
down so the body will flow into the tail without

losing the shape of the body.

WEDGE

This drawing, showing surface contour lines, should illustrate this rounding and curving as it applies throughout the entire fish.

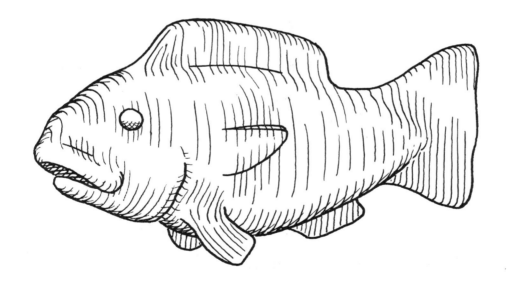

Sanding is not absolutely necessary but it is suggested. Sanding imparts a smooth, even surface

which is further enhanced by three coats of a clear lacquer or varnish.

At this point I would not suggest using any paints or tinted colors as the subtle variations in tone and color are very difficult to obtain. (Notice I said difficult, not impossible.) Stick with a clear finish for now, and eventually graduate into tinting your creations as you learn more about your subject. A clear finish will bring out the grain and pattern of the wood and show off your carving to its best advantage.

displaying

Now that you have whittled your model of a fish you'll want to "prop it up", so to speak, in such a manner that will show it off to it's best advantage.

There are many ways to accomplish this. I'll set forth a few, but if you will use your imagination I'm sure you will find others that might suit you better.

The first method is simply to use a dowel stick. A 3/16" or 1/4" dowel is satisfactory and should be readily available in lumber yards or hobby stores. Saw or carve out a base, preferably using the same kind of wood as you used for the fish. The shape of the base is left to you; square, rectangular, round, oval, or free-form. A piece of driftwood or a section of a well-weathered tree can also be quite effective.

Lay your whittled fish on top of the base determining just where you want it placed. Carefully mark with a dot, both the base and the stomach of the fish. Be sure the dots line up. Using the correct size drill bit, drill the two holes, being sure the drill is perpendicular to the wood surface. Drill the holes about ¼" deep. Cut off a piece of your dowel stick ½" longer than the distance you want between the base and the stomach of the fish. A drop of glue on both ends of the dowel is sufficient to bond everything together as you force fit the dowel into the base and the fish onto the dowel.

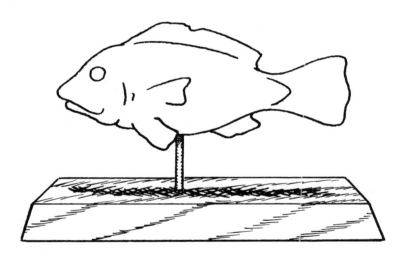

Another simple method is to use a short length of stiff wire. A piece of wire coat hanger is ideal. The procedure is the same, except you will drill the

clearance holes at a slight angle. The wire can be bent to the shape of a graceful curve.

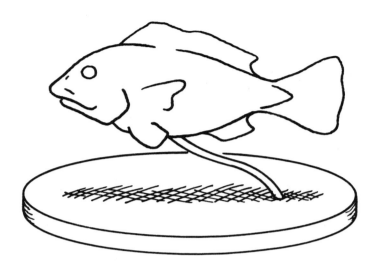

If, after you've completed your fish, you find there is no room on a table or shelf for your display, you may wish to convert your handiwork into a wall plaque. Ready-made plaques can be bought in most hobby stores or you can make your own if you desire.

Place the fish against the plaque and mark the plaque and the side of the fish, lining up the marks. Drill the clearance holes, being careful not to go too deep. A quarter of an inch is plenty deep enough. Place a drop of glue on the end of the dowel, insert it into the hole in the plaque and press it into place. Put a drop of glue in the hole in the fish and press the fish onto the protruding end of the dowel.

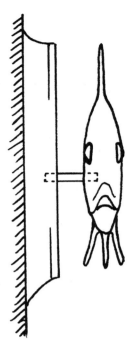

SIDE VIEW OF
WALL PLAQUE
MOUNTING

Other methods of displaying your work could include a marine setting to various levels of detail. A shadow box with a painted backboard sounds interesting. It could be accomplished using the same procedures as just mentioned for the wall plaque.

Miniature shells can be used to advantage by placing one, or a few of them, on the base after you have mounted your fish.

A piece of white cotton line, (rope), will dress up the edges of a plaque or base. The possibilities are almost endless.

Let your imagination take over!

I have whittled my interpretations of sea grass, curved and graceful, flowing in imaginary currents. Most of my fish have been carved in walnut, as are the bases. The curved and twisted sea grasses are also carved in walnut. The base of the grass blades are glued into small slots in the base, and the fish body is doweled and glued to a flat section of a single blade of grass.

Up to this point we've covered about all the basic instructions for whittling and mounting fish in general. Use these basic instructions as you move on to definite species of fish.

The following patterns can be enlarged or reduced to a size that will fit your liking by referring to the information on page 118. As a point of interest, I have whittled these patterns the same size as you see them in the following pages.

patterns

SHEEPSHEAD

A salt-water fish. Averages 1 to 4 pounds. Has a steep profile and a chunky body outline. Has sharply contrasting vertical light and dark bars similar to a convict uniform.

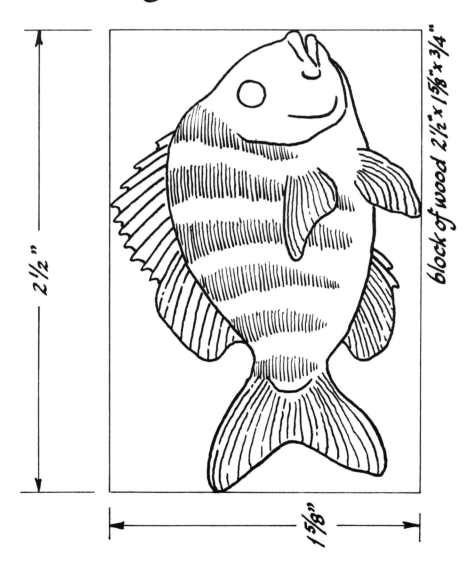

2½"

1⅝"

block of wood 2½" x 1⅝" x 3/4"

<u>CHANNEL BASS (REDFISH)</u> – Weights vary from 5 to 20 lbs. In more northern Atlantic waters it is known as "Red Drum". Body is heavy and powerful, the tail squared off. Large black spot at the base of the tail fin. Copper or bronze-colored in Florida waters.

Block of wood: 3¾" x 1¾" x 1¼"

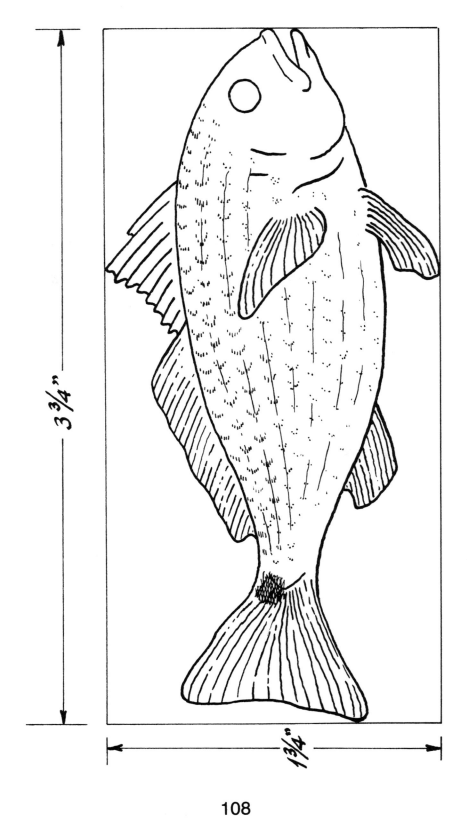

3 ¾"

1 ¾"

108

TROUT – Speckled or spotted seatrout (the spotted weakfish of northern waters). They run up to 6 to 8 lbs. for a good size on Florida's East Coast. Black spots appear on upper sides and back, and on the second dorsal fin and on the tail. Sides are silvery, the back grayish to dark. The tail is squared and slightly concave.

Block of wood: 4"x 1⅝" x 1¼"

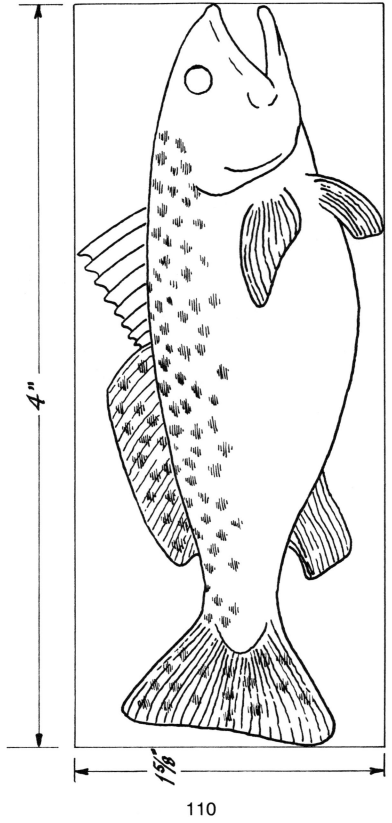

4"

1⅝"

110

MANGROVE SNAPPER – Usually run from 1 to 2½ lbs. Dark bands mark the back, the sides are reddish to gray. Both the dorsal fin and the tail fins are dark. The pectoral and the anal fins have a slight pinkish hue.

Block of wood: 4" × 2" × 1¼"

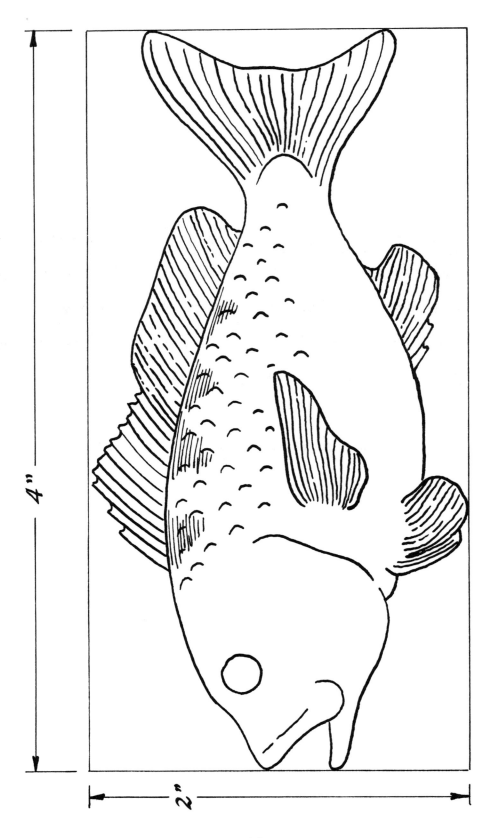

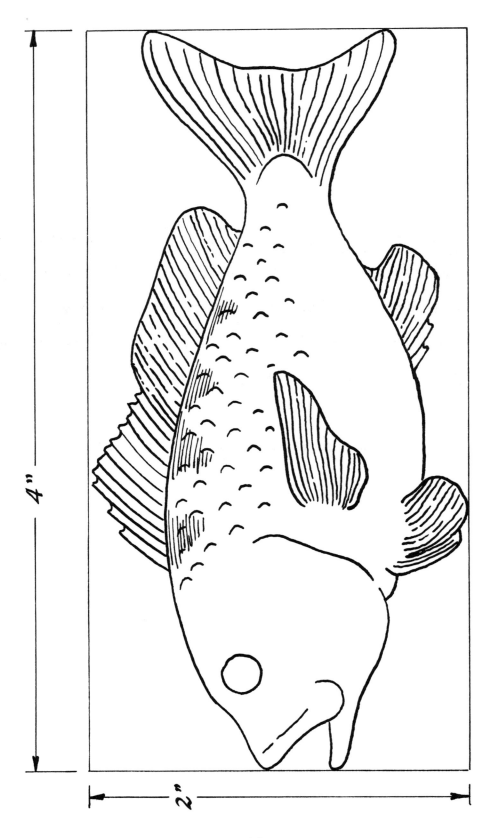

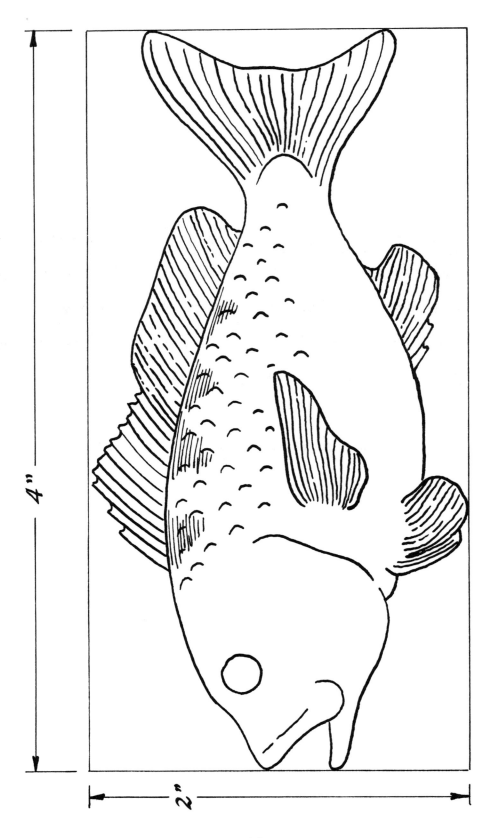

4"

2"

<u>BLUEGILL</u> – A fresh-water fish. The most popular member of the panfish family, more commonly called bream (pronounced "brim"). Also known as the bluegill sunfish elsewhere. Can measure up to 12" and weigh 2 lbs. when full grown. Dark olive overcast with a purple luster on the back. Belly has a reddish cast. Dark bars on sides and black spot on gill covers. Cheeks and jaws a purplish blue.

Block of wood: 4" x 3" x 1½"

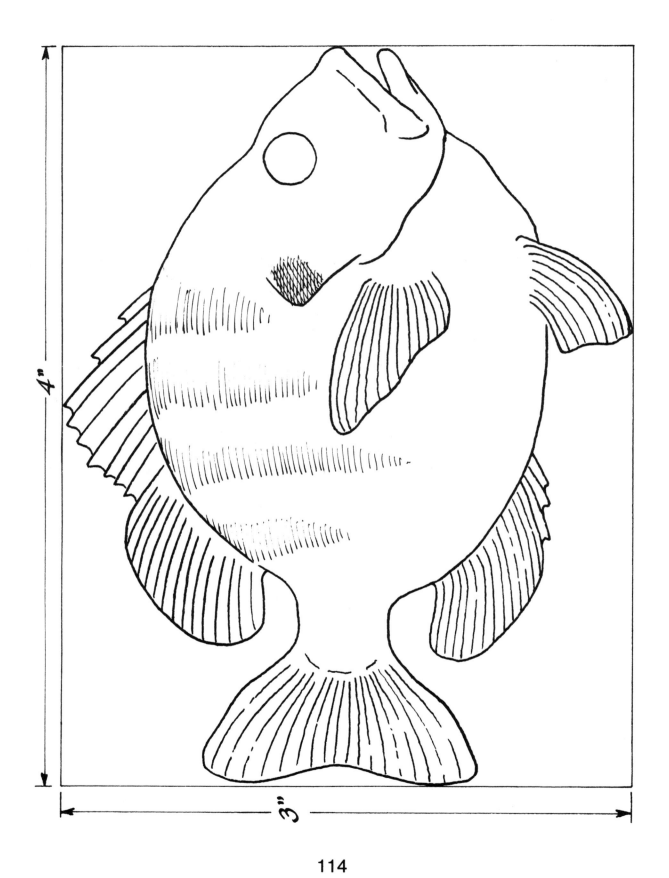

4"

3"

114

SHARK - There are many varieties. This one is a Tiger Shark. Average about 10 ft. with a weight of 600 lbs. Full grown, they can reach 14 ft. and weigh 1200 lbs. They have tremendous speed and are considered quite dangerous. Upper body is dark blue-gray, with faint vertical markings. The upper ½ of the tail is elongated, the nose is blunt.

Block of wood: 3½" x 1" x 1⅛"

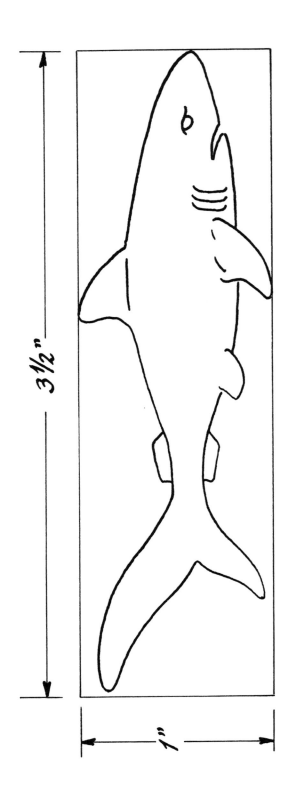

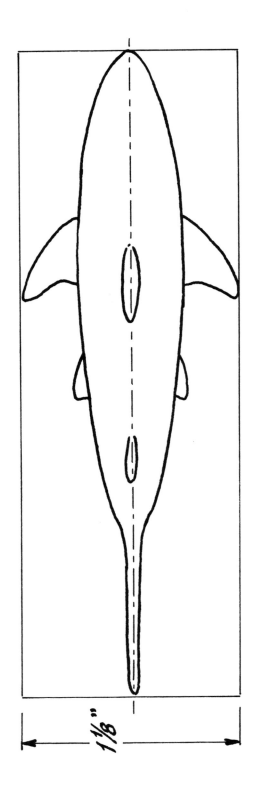

3½"

1"

1⅛"

116

Study underwater photos of fish in action. Notice how their bodies curve and twist, and incorporate these actions into your work as you progress on these and other species. Study the intricate and subtle colorings of fish.

As you advance in whittling fish you may become so absorbed in the work that you will want to enter the specialized field of fish carving. That is, to carve and color your fish to museum-like qualities.

grid system

There will be many times that a reference photo or drawing would be an excellent pattern for a carving, except that it is the wrong size. It either won't fit the block of wood you have, or it is inconvenient to handle.

You can enlarge or reduce any photo or drawing by using the "grid system".

Draw a ½" grid, which is a series of vertical and horizontal lines, spaced evenly ½" apart, on either the original drawing or a tracing of the drawing.

I have found the ½" squares convenient to work with, however you can use any measurement you'd like to. Just be sure your grid is accurate.

Next, on a sheet of blank paper, draw a new grid. The size of this grid depends on how large, or

how small you wish your finished product to be.
For instance, if you wish to have it double the size
of the original drawing, draw your grid with 1"
measurements.

If you wish a half-size product, draw your
grid with ¼" spacing.

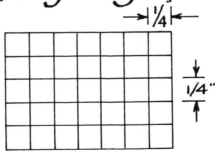

Now simply draw in each box of your second
grid what you see in the original.

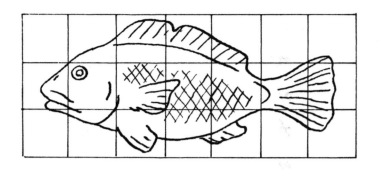

ORIGINAL

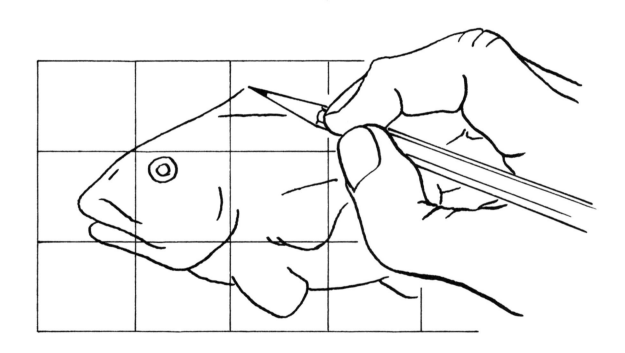

ENLARGED TO DOUBLE SIZE

120

Your drawing will be identical to the original, except in size.

You are now ready to transfer your drawing to a block of your favorite whittling wood.

This "grid system" method can be used for almost any type of enlargement or reduction. Among the many applications would be enlarging a sketch for a poster, or laying out a wall mural from a photo.

background

Interest is reawakening in the folklore of the "little" people. Tales from out of the long ago tell of Elves and of Fairies, of Pixies and of Brownies, of Goblins and of Trolls, of Leprechauns and of Banshees, of Dwarfs and of Gnomes, and of many, many other races.

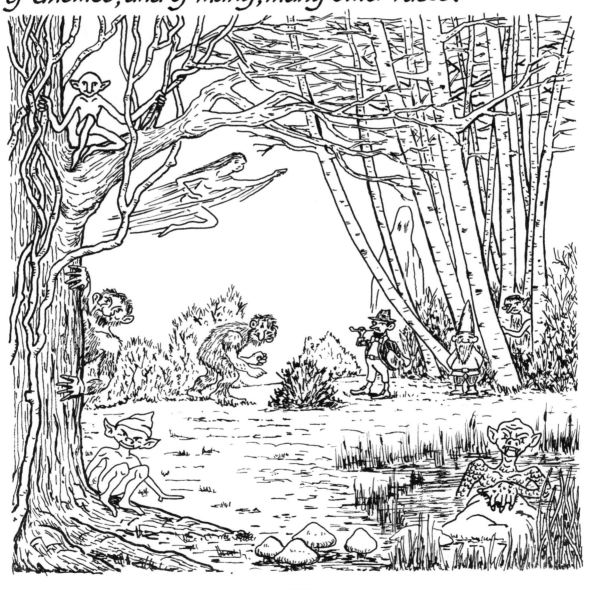

Of all of these races, the Gnome seems to have the reputation of being the most benevolent to man. He is friend to man, to animal and to bird. While most folklore and legends are in the realm of fantasy, there are many humans who, even today, claim to have seen these small, wondrous creatures. Gnomes are truly remarkable creations and it is with a great deal of pleasure that I share with you a part of their story.

history

The story of the gnome is a fascinating tale. It is unfortunate but we know very little of their former days for they appear to have kept no written records of their history or background. As far as we can tell they may have been on earth shortly after creation. Gnomes are an extremely adaptable race and could have easily managed to survive through the ice ages that engulfed this planet long ago.

We must rely solely on our own sightings and recordings of these noble people.

The first recorded sightings of gnomes were made over two thousand years ago. At that time they inhabited an area called Scandanavia in northern Europe. Nordic legend and folklore are filled with tales of little people, hardly more than shoe-top high, skipping across the snow-covered fields, caring for injured birds and small animals. Many

125

tales are told of the aid the gnomes have given to man. It is told of how they tended to the farmer's livestock when the farmer's family took ill, of how they brought food for the people when severe winter storms cut off other supplies, and of how stranded travelers kept warm through nights of bone-chilling cold by gnome-built fires.

People who had contact with the gnomes in that day made carvings out of wood to describe what they had seen, and these carvings have been passed down through the ages by some of the families that dwell in what is now known as Norway and Sweden.

AN OLD WOODCARVING
FOUND IN NORWAY

It appears that some gnomes started to migrate about the year 800 A.D. Sightings and stories of these gnomes were reported about that time in the flatlands of central Europe, areas that are now Germany, Holland, and Denmark.

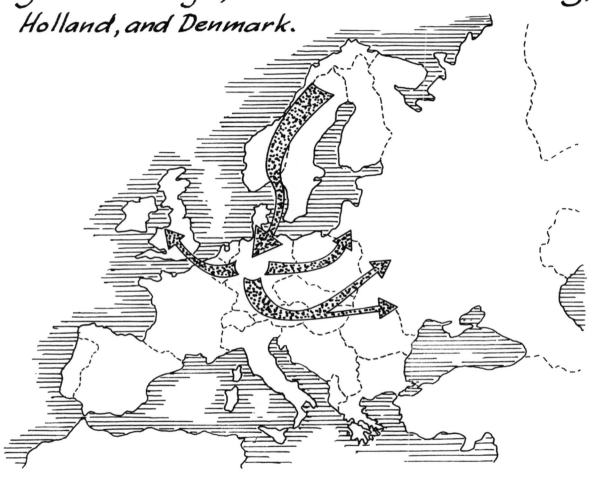

Their migration continued, and in the next few hundred years they seem to have made their way across the channel to England and Ireland. Others turned to the east and populated Austria, Hungary, Czechoslavakia, Poland, and Russia

As their society continued to expand, a few hardy gnome families crossed the ocean on some of the first vessels that sailed to the new world. They now inhabit portions of the United States and Canada.

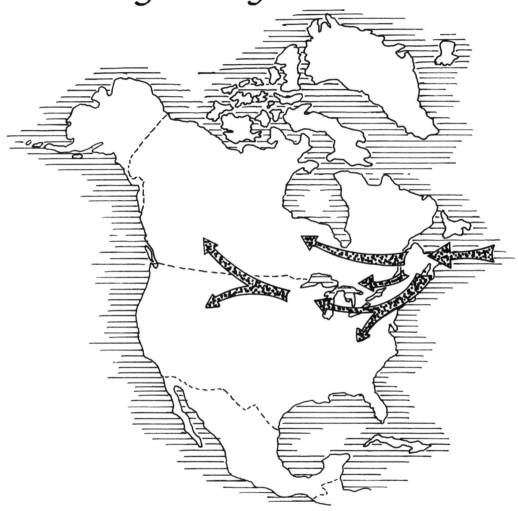

These little people enjoy the cold and cooler temperatures and shun the heat of the tropic and semi-tropic regions of earth.

Legends from the past mention a gnome-king

and his royal court in an underground castle and all of the splendor befitting such a high position.

The king and his queen ruled with a wise and gentle hand and peace and harmony lay on the lands of his realm. Not too much has been learned of the ruling families lately. There may still be such a royal family hidden in the snow-covered wilderness of Norway but if it does still exist it is but one more of the well-kept gnome secrets.

The civilization of man, with his wars and his polution of the environment, has forced the gnome to retreat deeper and deeper into the forests. Alas, they are fewer in number today than they were but a century or two ago. Let us pray we do not become so "civilized" that we cause the gnome to fall into extinction or to dull our imagination to the point that we can no longer picture this proud and independent creature running across the fields, flitting from tree to tree, and living in harmony with all of nature.

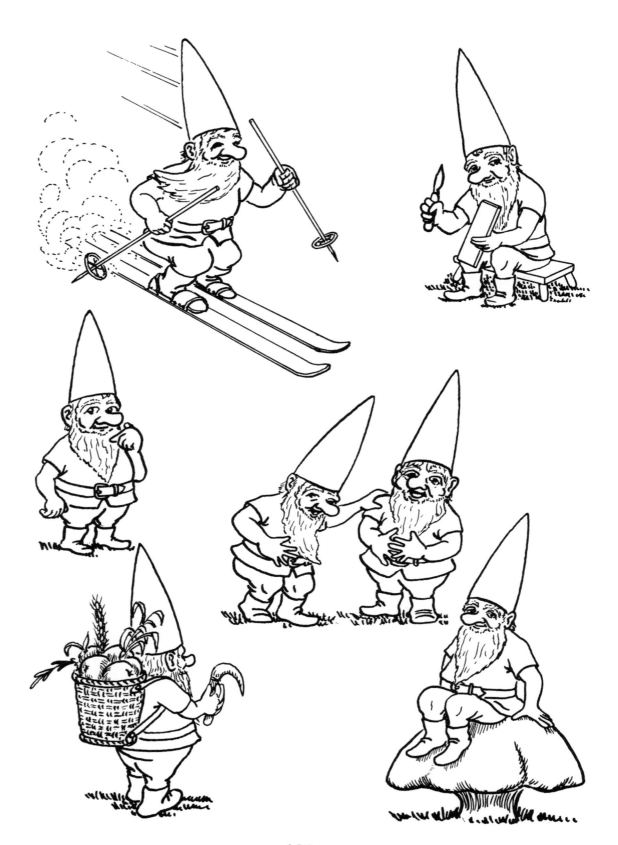

features

The adult male gnome attains a height of 4 to 4½ inches. There have, however, been numerous sightings of taller gnomes, some reaching a height of almost 6 inches.

Gnomes are somewhat chubby, weighing about 10½ ounces on the average. The life-span of the gnome is about 400 years. They reach maturity at age 100 at which time their beards grow quite full and turn white. The upper lip is void of hair, so you'll never see a gnome with a mustache. The nose is quite large in proportion to the rest of the facial features.

They are exceedingly strong for their size and can perform amazing feats of strength in comparison to man.

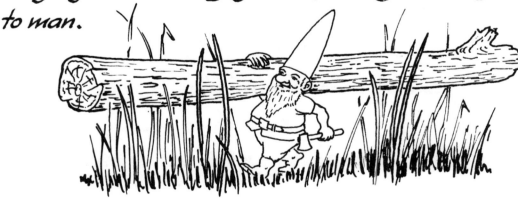

These little people can run across the fields and meadows at incredible speed and can easily outdistance

most predatory animals which might take a notion that the gnome would make a tasty morsel.

Gnomes are twilight or night people as a rule. They sleep during the day and work at night. They prefer staying out of the sun's rays because the harsh glare of daylight hurts their eyes. Only if they have a very important errand or chore will they dare to venture forth in daytime.

The gnome can be easily recognized by his tall, red conical hat. He wears a cloth shirt, bluish in color, and his pants are a brownish green. Around his waist he dons a wide leather belt with a brass buckle. Small boots of soft leather cover his feet when he is outside.

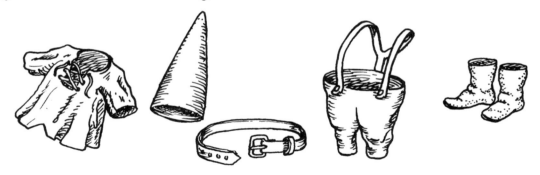

He usually goes barefoot at home. Gnomes like to sit and wiggle their toes while smoking on a pipe.

Gnomes are excellent craftsmen. As woodcarvers and carpenters they have no equal even with their primitive tools. Working with wood is their first love and they will toil for endless hours to create carvings and

furnishings for their homes.

The adult female gnome is just slightly shorter than the male, being 3¾ to 4 inches in height. Her average weight is about 9 ounces.

Little is really known about the female for she is seldom seen by humans. She contents herself by remaining indoors most of the time tending to her household chores and in caring for and raising her offspring.

The gnome woman is well skilled in the use of the spinning wheel and the loom. She makes her own

thread and weaves it into the cloth from which she tailors clothing for her husband, children, and herself.

The unmarried girl is taught these skills by her mother. The unmarried girl can be recognized by the green cone-shaped hat that she wears. Her golden blond hair is plaited into long braids on either side of her head and tied with red bows. She wears no scarf on her hair.

Her mother however, being married, wears a dark purplish-gray cone-shaped hat. A scarf of a

lighter shade of purplish-gray embroidered in red is an additional covering over her graying hair.

A blouse, matching the color of the scarf, is worn and is tucked inside the waistband of her long olive green skirt. The blouse is embroidered in red thread across the shoulders and collar similar to the scarf. Her feet are covered with small furry shoes.

Gnome children are almost never allowed out except for a few minutes at twilight time and then only under the constant and watchful eye of their father.

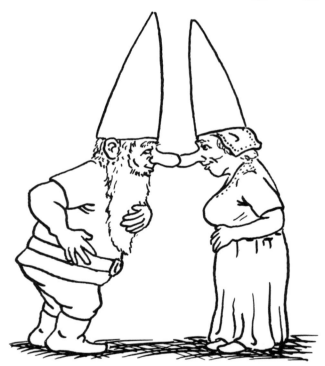

A curious custom of the gnome is that of rubbing noses with his wife. This ritual replaces that of the kiss and

the spoken words for "Hello", "Goodbye", and "Goodnight".

Gnomes do not eat meat. Therefore they have no need to hunt and kill animals. Quite the contrary, they often tend to the sick or injured animals and birds restoring them to health. They are renowned for their magical herbs and potions which have great healing powers.

By far, most gnomes live in burrows just under the ground at the base of heavily rooted old trees on the outskirts of the forests. These burrows are comfortable little homes with doors, walls, ceilings and floors made of wood. Lit by candlelight, they are completely furnished with tables, chairs, beds, dressers, stoves, and bathroom facilities. Everything is hand-made and is built to last many lifetimes.

A gnomes life is a healthy and happy one. They do not overeat and enjoy mealtimes of fruits and greens from the meadows. Milk is their main beverage which is freely given to them by friendly cows and goats nearby.

Running and jumping from place to place and working hard give them plenty of exercise.

They enjoy a pipeful of tobacco and an occasional drink of a mildly alcoholic homemade wine.

Gnomes do have a few natural enemies, such as skunks, cats, snakes, and hornets. However their tremendous speed allows them to outdistance most of the animals. Hornets are seldom found at night and although their sting can be quite painful to these little people, various herbs and potions nullify the poisonous effect and recovery is speedy.

whittling

The whittling of these fanciful creatures is not really difficult, but it does require a bit of patience and a real sharp knife.

The patience you will have to develop yourself. Just relax, take your time, and don't try to cut off too much wood at one time. Whittling is a hobby that shouldn't be rushed.

The sharp knife can be your favorite pocket-knife honed down to a keen edge, or any assortment of various blades and handles available today. I favor the sturdy 1/2 " blades set in a brass chuck handle.

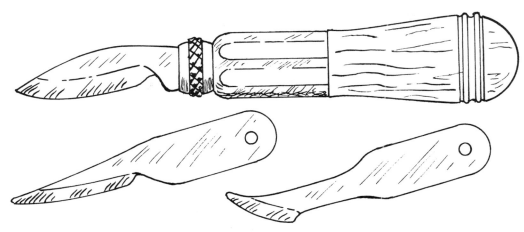

KNIFE WITH 3-BLADE ASSORTMENT

For figure whittling I like to work with basswood. Fine detail can be obtained and the wood does not split too

137

easily. This wood will accept watercolors, acrylics or oil colors.

We will use the patterns of a standing gnome shown on pages 151 and 152.

Begin by tracing the outline of the front-view pattern. Make another tracing of the side-view pattern. Transfer these patterns to the proper size block of wood. This can be done by slipping a sheet of carbon paper between the tracing and the wood and going over the outline drawing with your pencil.

(The patterns contained in this booklet can be enlarged if you wish by using the "grid-system". This method of enlarging or reducing a drawing is fully covered on page 118.

After you have both the front and side views on your block of wood you are ready to use either a jigsaw, coping saw or bandsaw to remove the excess wood.

Start by following your front outline part of the way up the block. Stop, and saw from the other end, leaving about a fourth of an inch gap between the saw cuts.

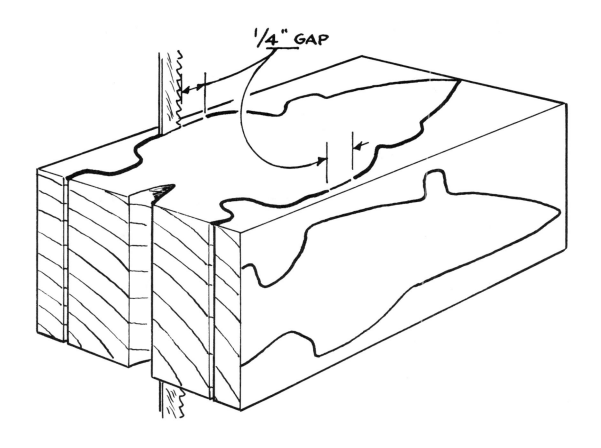

These gaps will allow the block to remain in one piece and still rectangular so you can easily saw the side-view outline. When the side-view has been cut you can now go back and cut through these gaps.

This technique of sawing an outline blank from a block of wood should be used whenever you are going to whittle any three-dimensional object, regardless of the subject matter. It'll save a lot of work and frustration.

Your block should now look similar to this.

SAWED-OUT BLANK

Refer to the pattern and sketch in, with your pencil,

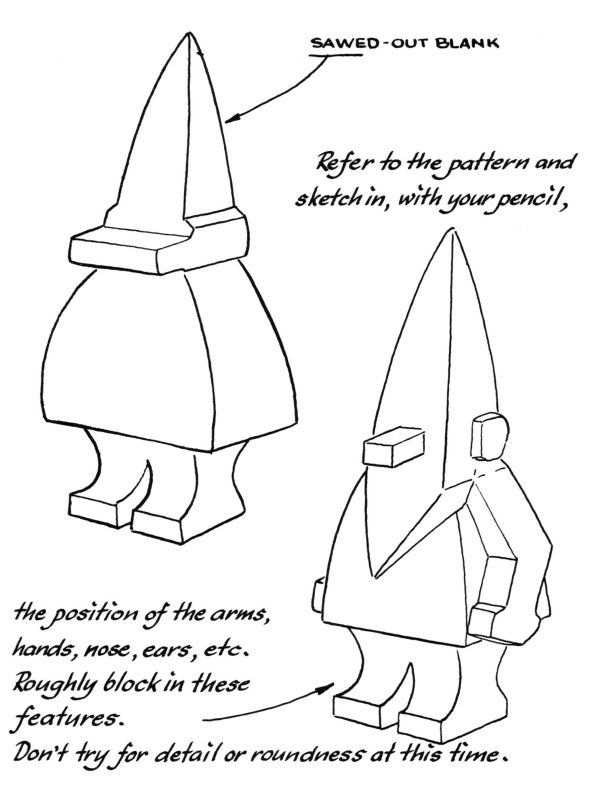

the position of the arms, hands, nose, ears, etc. Roughly block in these features. Don't try for detail or roundness at this time.

The idea right now is to capture the overall position of the figure. When your figure resembles the previous sketch you should be able to visualize the completed figure.

Start a general, all-over rounding. No details yet. Work a little on the legs, on the body, on the hat, on the arms, then go back again and work a little more on the legs, body, etc. This will allow you to make minor corrections and changes as you progress. Keep working on the overall figure.

The extent of detail is your choice. I'll illustrate what I prefer. You may prefer a little more or a little less.

The following series of illustrations will show you how to arrive at the various details through a sequence of steps. It is _not_ suggested that you start any one element and finish it to completion before starting another. Just rough in all the various sections, then go back and refine each a little. Go back again and add a few more cuts as you continue to work the entire figure. The final cuts will probably be very small shavings and notches, just enough to give your work the look of a master craftsman.

141

The hands evolve from the knobs at the end
of the arms.

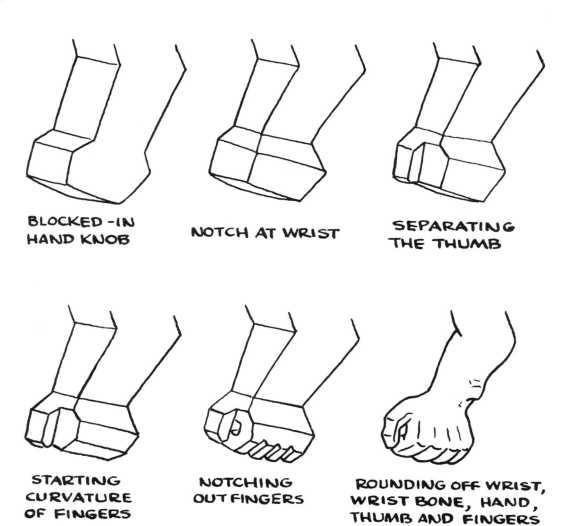

BLOCKED-IN
HAND KNOB

NOTCH AT WRIST

SEPARATING
THE THUMB

STARTING
CURVATURE
OF FINGERS

NOTCHING
OUT FINGERS

ROUNDING OFF WRIST,
WRIST BONE, HAND,
THUMB AND FINGERS

The feet are covered with boots so the detailing
is less.

BLOCKED-IN
FOOT

NOTCH AT TOP
OF BOOT

GENERAL
SHAPING

ROUNDING-OFF
LEG & BOOT, ADD
CREASES & HEEL

142

The area of the mid-section is whittled away to leave a belt around the body with enough wood to form a buckle in the front.

BLOCKED-IN MIDSECTION.

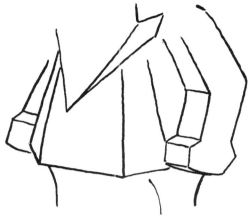

CUT THE FOUR CORNERS TO MAKE THE MIDSECTION 8-SIDED.

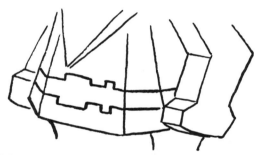

DRAW THE OUTLINE OF THE BELT, BELTLOOP & BUCKLE.

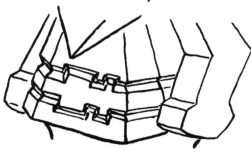

NOTCH THE BUCKLE, BELT LOOP AND BELT OUTLINE. CONTINUE THE BELT OUTLINE ALL AROUND.

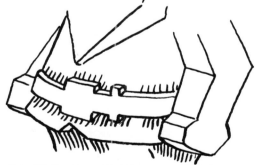

ROUND OFF THE MIDSECTION LEAVING THE BELT, BELT LOOP AND BUCKLE PROTRUDING.

143

At this time you're ready to put the finishing details to the buckle and loop.

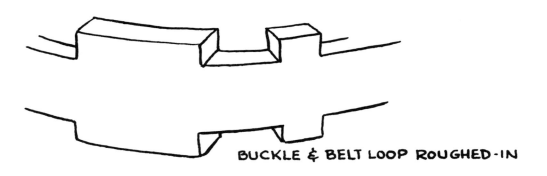

BUCKLE & BELT LOOP ROUGHED-IN

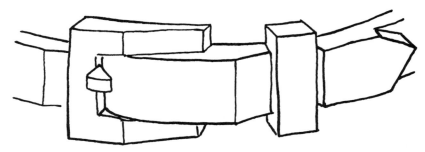

MAKE CUTS TO INDICATE BELT THICKNESS
AND BUCKLE SHAPE

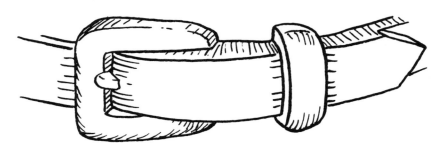

ROUNDING OFF TO FINISHED SHAPE

The ears are blocked-in. They should be the same size and shape and located evenly on the sides of the head. The whittling is simple. Draw the

inside and outside outlines of the ear, hollow out the
inside, round off the outside, and finish shaping.

BLOCKED-IN EAR

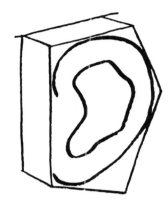

DRAW EAR OUTLINE

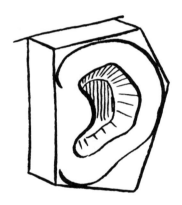

HOLLOWED OUT INSIDE

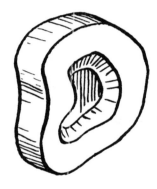

ROUNDED OFF OUTSIDE

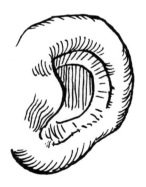

FINISH SHAPING

The facial features start as a series of notches
and then are formed to appear as cheeks, eyes, mouth,
and nostrils.

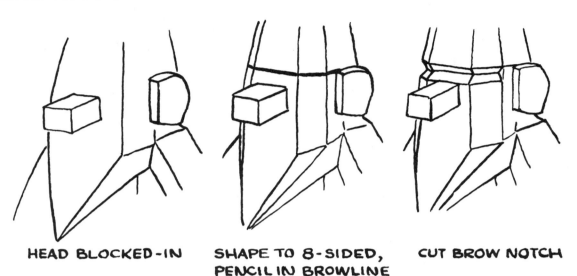

HEAD BLOCKED-IN SHAPE TO 8-SIDED, CUT BROW NOTCH
 PENCIL IN BROWLINE

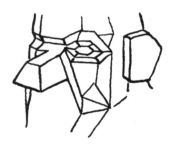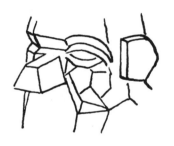

SLANT SIDES OF NOSE, CURVE BROW ARCH, ROUND OFF EYEBALL
CUT CHEEK NOTCH NOTCH LOWER CURVE SOCKET, EYEBALL,
 FORMING EYEBALL, AND CHEEK.
 NOTCH UNDER CHEEK

The following three sketches show an ideal way
of portraying a carved eye. You are working on a small
scale and this kind of detail is difficult but the result
is worth the effort. Practice on a larger scale if you wish.

146

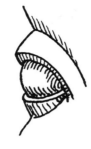

SIDE VIEW FRONT VIEW 3/4 VIEW

The nose is developed in easy steps. Take care! The nose is across the grain and it is one of the weakest parts of your project.

NOSE BLOCKED-IN FORM NOSTRILS ON SIDES SHAPE END OF NOSE ROUND OFF NOSE & NOSTRILS

The mouth is a slightly curved "vee" cut with a triangular notch at each end. A shallow indentation under the mouth cut will form the lower lip. The upper lip need not be indicated.

THE BASIC NOTCHES THAT FORM THE MOUTH

147

The hair and beard can be carved as a mass with just a few "vee" cuts to indicate the direction of the natural flow of hair.

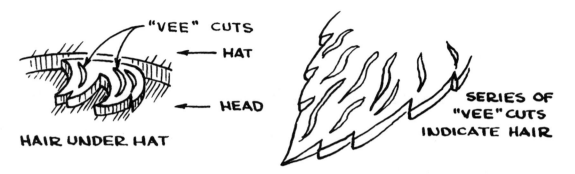

HAIR UNDER HAT

"VEE" CUTS
← HAT
← HEAD

SERIES OF "VEE" CUTS INDICATE HAIR

Wrinkles in the clothing, especially at the stress points, are also shown with a few "vee" cuts.

As you work on these gnomes or any other figure remember that the face and hands are the most expressive features of the body. Practice on scraps of wood. You'll be surprised at the expressions you can describe once you have the flair for whittling details.

When you have decided that your little gnome is completed you may wish to sand the figure lightly. This is strictly a matter of preference. If you do use a fine garnet paper (I prefer the 150 grit) or sandpaper take care not to use your knife blade again on the figure. Small bits of the abrasive imbed into the wood fiber and will dull a sharp knife edge quickly.

One of the characteristics of basswood is the overall "dead" color of the wood. You will probably want to paint your figures.

Watercolors, acrylics, or oils can all be used satisfactorily.

Where two different colors meet, for example, arms and sleeves, beard and chest, etc., I make a knife cut at the dividing point. This cuts the fibers of the wood and helps prevent the one color from "bleeding" into the other area. Not a notch, just a cut.

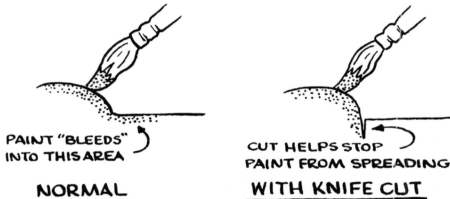

PAINT "BLEEDS" INTO THIS AREA

NORMAL

CUT HELPS STOP PAINT FROM SPREADING

WITH KNIFE CUT

The skin should be flesh colored with just a touch of pink on the cheeks and nose. The beard and hair will be white. White acrylic works better than watercolors for the beard and hair.

The other colors can be determined from the gnomes description on pages 132, 133, and 134.

When the paints are dry, two or three coats of clear lacquer or varnish can be applied to protect the painted finish of your gnome.

Now that you have your cute little creature finished you are ready to start work on the other projects. Follow the whittling procedures as you did for the standing gnome. Keep your blade sharp and take your time. It's a lot of fun to whittle out these imaginative figures so don't hurry. Learn to enjoy the hobby of whittling.

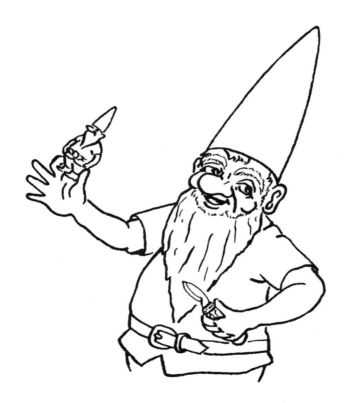

patterns

1⅝ "

4¼ "

FRONT
VIEW

STANDING
GNOME

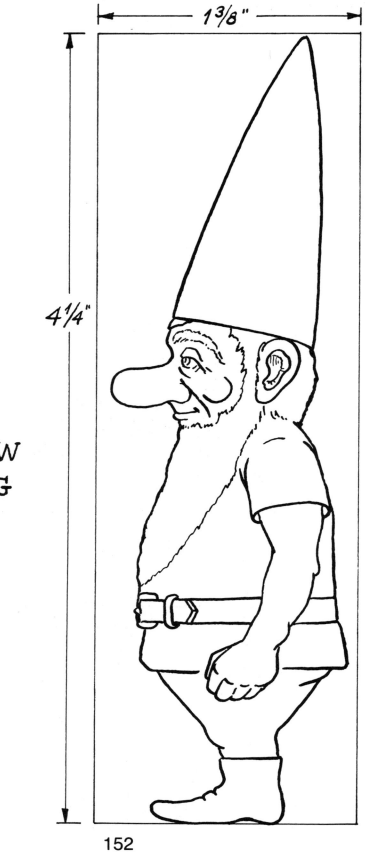

1³/₈ "

4¹/₄ "

SIDE VIEW
STANDING
GNOME

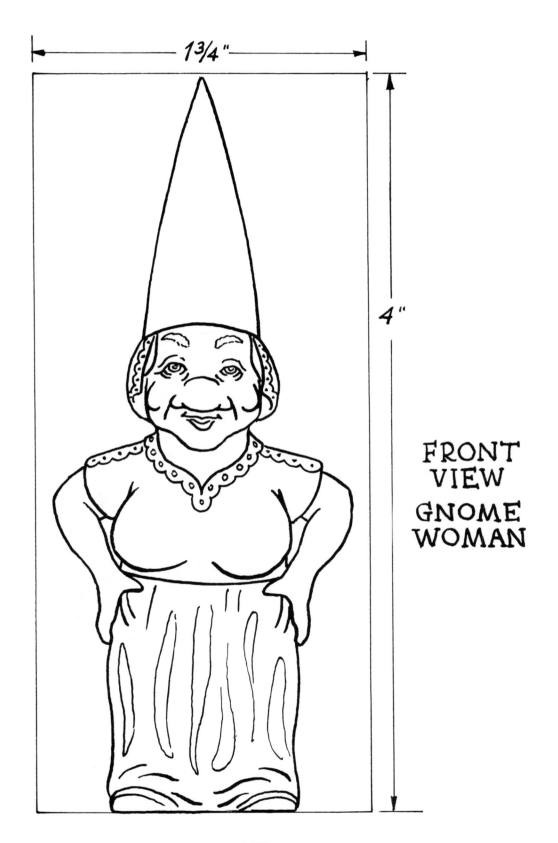

1¾"

4"

FRONT
VIEW

GNOME
WOMAN

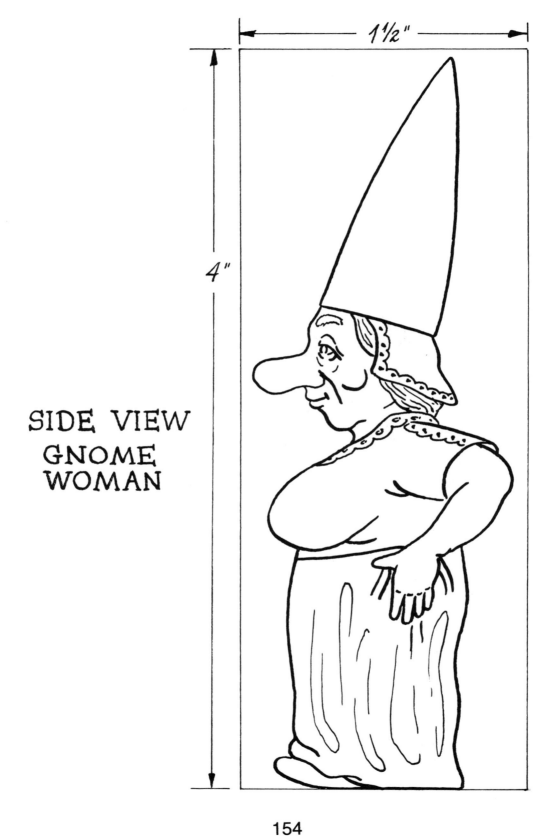

SIDE VIEW
GNOME
WOMAN

154

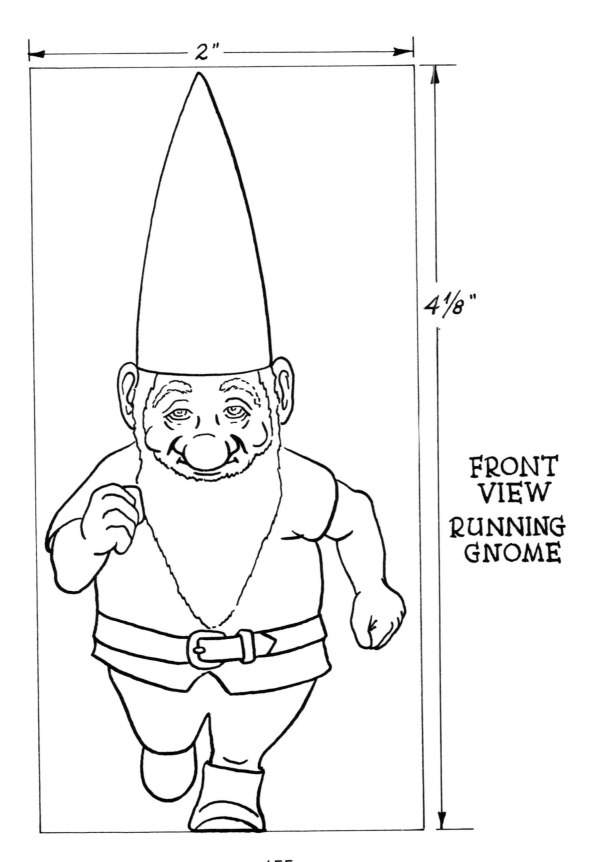

2"

4⅛"

FRONT
VIEW
RUNNING
GNOME

155

2¹/₄"

4¹/₈"

LEFT
SIDE
VIEW

RUNNING
GNOME

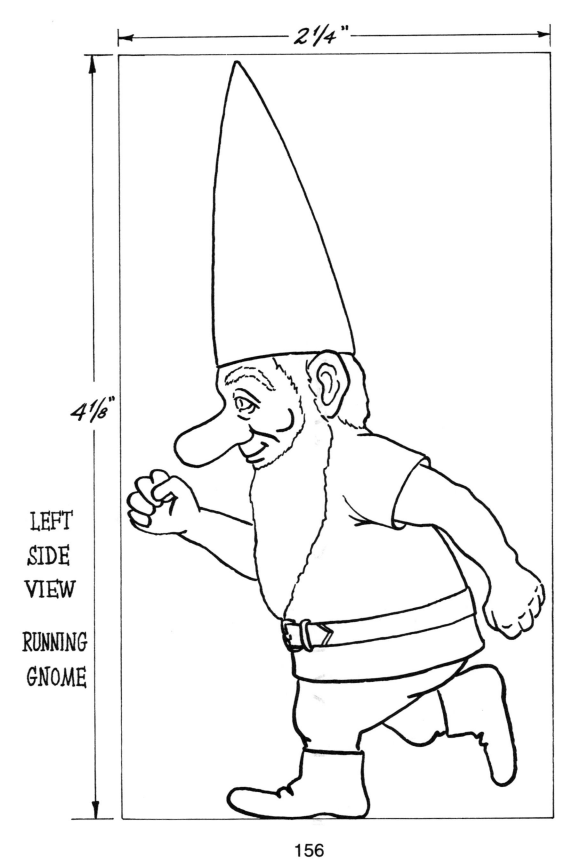

156

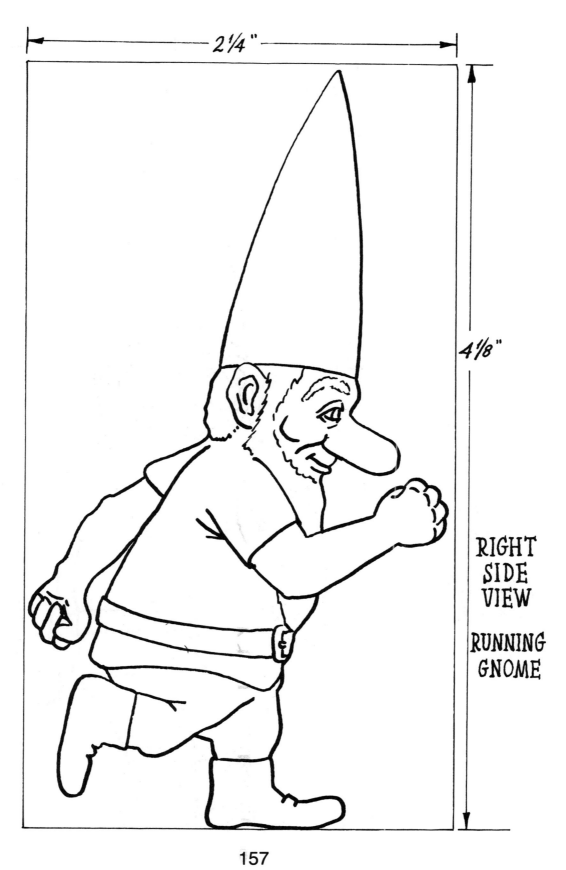

2¼ "

4⅛ "

RIGHT
SIDE
VIEW

RUNNING
GNOME

157

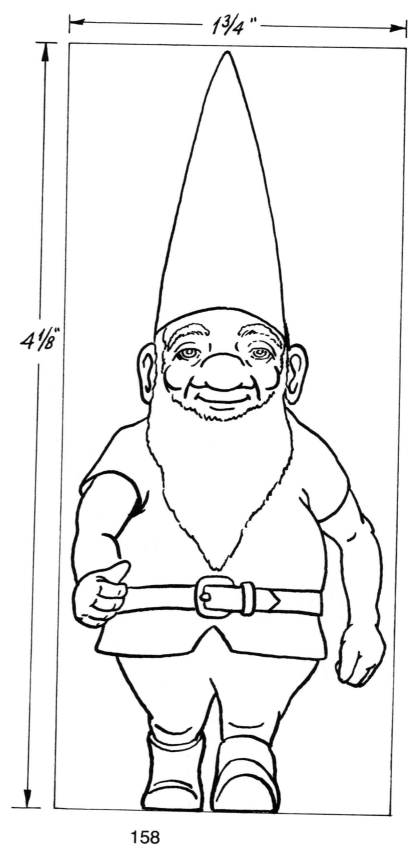

1¾ "

4⅛"

FRONT
VIEW

WALKING
GNOME

158

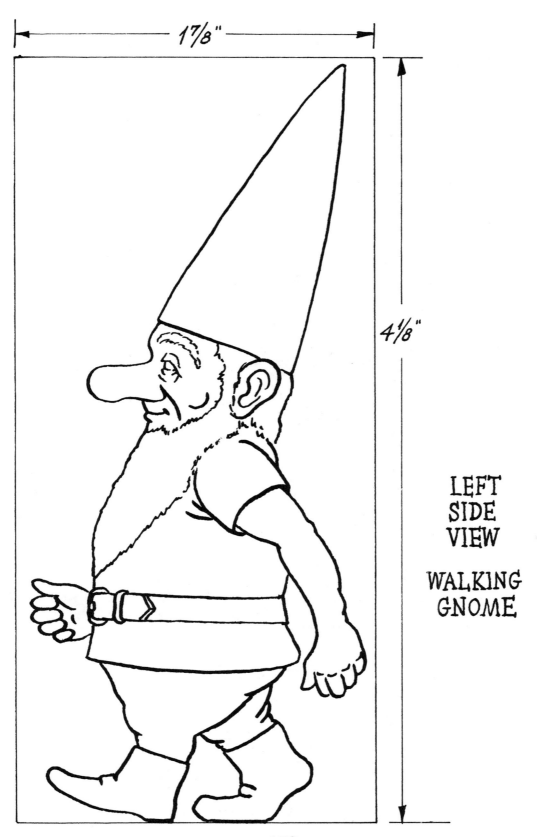

1⁷⁄₈"

4¹⁄₈"

LEFT
SIDE
VIEW

WALKING
GNOME

159

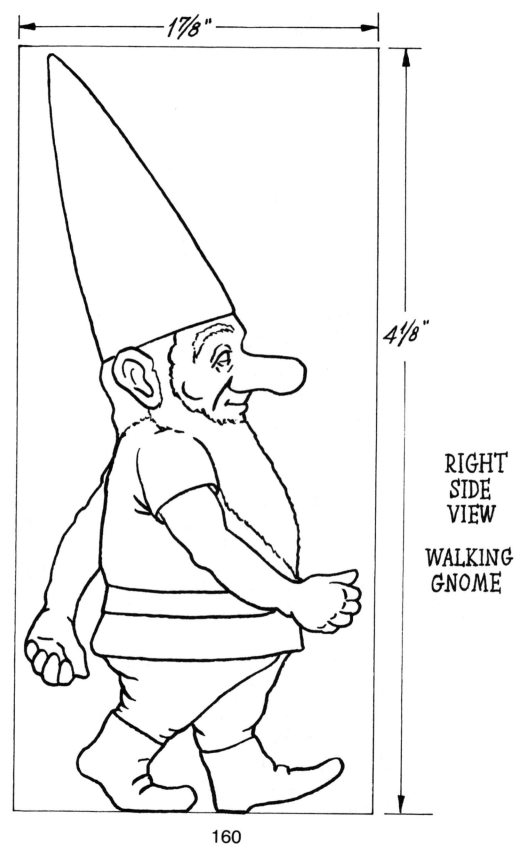

1 7/8 "

4 1/8 "

RIGHT
SIDE
VIEW

WALKING
GNOME

160

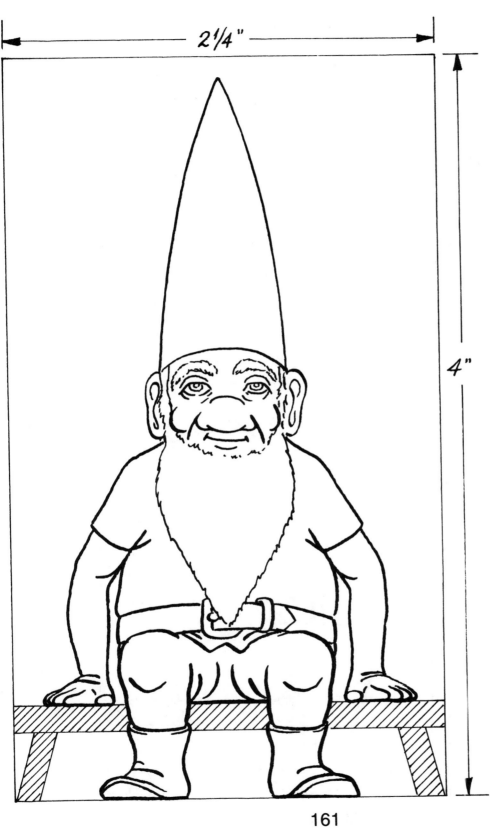

2¼"

4"

FRONT
VIEW

SITTING
GNOME

161

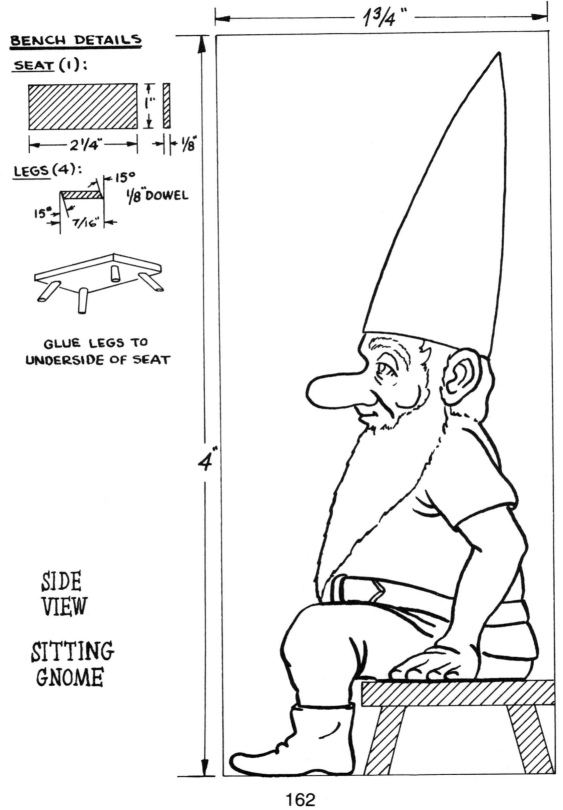

BENCH DETAILS

SEAT (1):

1"

2¼"

⅛"

LEGS (4):

15°

⅛" DOWEL

15°

7/16"

GLUE LEGS TO
UNDERSIDE OF SEAT

1¾"

4"

SIDE
VIEW

SITTING
GNOME

162

bibliography

ADDITIONAL READING MATERIAL AND INFORMATION

Publications of special interest to Whittlers.

The Mallet
> The publication of The National Carvers Museum, a nonprofit foundation dedicated to teaching, encouraging and preserving the art of whittling.

> Address: The National Carvers Museum
> 14960 Woodcarvers Road
> Monument, Colorado 60652

Wonderful World of Wood
> A publication of the International Wood Collectors Society providing information on all aspects of whittling.

> Address: Mr. E. B. Himelich
> 601 Burkwood Court East
> Urbana, Illinois 61801

Books of interest to Whittlers.

The list of books available on whittling is very large and constantly changing with new additions. This list cannot be included here. The reader should contact The National Carvers Museum, local library, and local bookstores and ask to see the available books.

Whittling Clubs.

There are whittling clubs in every State and many other countries. For the location of a club in your area send a stamped-self-addressed envelope to The National Carvers Museum. They will be happy to answer any questions to help you.

index

FOUR NEW BOOKS FOR THE WHITTLER AND WOOD-CARVER

SCULPTURING TOTEM POLES

Walt Way has prepared a Do-It-Yourself book with large clear drawings showing exactly how to proceed with a chain saw, mallet, knives, and gouges to carve a four-foot Kwakiuti Totem and a seven-foot Haida Alaskan Totem.

The instructions show the novice and the expert carver how to remove the correct amount of wood in the right places to complete a classic totem. The results will be a Totem representing art-forms and religious symbols to the Indians of the Pacific Northwest and Canada. He includes historical information about totems, information about suitable woods, tools and equipment with suggestions as where the tools can be purchased. 8-½ x 11, paperback, 26 pages.

SELECTED BIRD PATTERNS FOR CARVERS

Fred Plaumann has prepared full-size carving patterns for 31 American Birds. These patterns may be taken directly from the book. He has included technical data sheets with dimensions and colors for each bird and complete carving and mounting instructions. This book provides the beginner and expert with excellent material for many projects. 9 x 12, paperback, 44 pages.

165

DRAWING AIDS FOR THE WHITTLER, WOOD-CARVER, AND ARTIST

Every Whittler, Wood-Carver, and Artist working in any other media should have basic skills in mechanical and freehand drawing. This book provides the easy-to-learn-and-use techniques and aids to help you. Each technique and aid is carefully explained and illustrated for immediate use without requiring many hours of practice. This 5-½ x 8-½ paperback book was prepared by Willard Bondhus and Phyllis Anderson. These two experienced Whittlers, Wood-Carvers, and Artists offer help in your enjoyment of woodworking and other areas of interest by the use of practical and timesaving drawing techniques and aids.

(This book is being printed. Please advise us of your interest and we will contact you as soon as the book is ready.)

HOW TO TEACH WHITTLING AND WOOD CARVING

A comprehensive manual for the beginning and experienced instructor of Whittling and Wood Carving. Easy-to-read-and-use drawings and step-by-step instructions for 17 projects help the instructor through all phases of teaching students. Detailed information in this 112-page, 5-½ x 8-½ book is provided to help the instructor understand the students, their motivations, and to assist them in developing their skills. Specific information is provided on the care and use of tools and how to select the proper wood(s) for each project. The authors suggest additional sources to obtain information on Whittling and Wood Carving Clubs, books and publications, and any required assistance in Whittling and Wood Carving.

(This Manual is being printed. Please advise us of your interest and we will contact you as soon as the book is ready.)

NOTES

NOTES

NOTES

NOTES